D0946577

AMERIKA

TIM ROLLINS + K.O.S.

AMERIKA

TIM ROLLINS + K.O.S.

EDITED BY GARY GARRELS DIA ART FOUNDATION, NEW YORK

TIM ROLLINS + K.O.S.

October 13, 1989 through June 17, 1990

548 West 22nd Street, New York

Library of Congress Catalogue Card Number: 89-051196

ISBN 0-944521-18-5

Funds for this exhibition and publication have been generously provided
in part by the Cowles Charitable Trust, The Jerry and Emily Spiegel Family Foundation,
the National Endowment for the Arts, a federal agency, Washington, D.C.,
and the New York State Council on the Arts.

This publication has been designed by Jean Foos and Jill Korostoff,
typeset by Trufont Typographers, Inc., and printed by
Abrams Gleber Warhover Lithographers, Inc.

CONTENTS

PREFACE AND ACKNOWLEDGEMENTS

The occasion for this book about the "Amerika" series of paintings by Tim Rollins + K.O.S. is the exhibition of the thirteen large-scale paintings in the series at the Dia Art Foundation, 548 West 22nd Street, New York, from October 13, 1989 to June 17, 1990. The exhibition also includes study drawings for *Amerika XII* and in addition, a new large-scale work based on Schubert's *Winterreisse* (1989). Following the program of the Dia Art Foundation, the "Amerika" paintings, drawings, and *Winterreisse* are presented in a specifically developed architectural installation. The exhibition is the first large-scale public presentation of the work of Tim Rollins + K.O.S., and the Dia Art Foundation is pleased to be able to sponsor and organize both the exhibition and this book about their work, especially here in New York, their base of activity.

Tim Rollins and the members of K.O.S. were extremely generous with their time and energy in all phases of the project, and we greatly appreciate their assistance in the design of the configuration of the second floor of our building for these works. Their efforts have significantly enhanced the strength of the exhibition. In preparing the space to the specifications of Tim Rollins + K.O.S., James Schaeufele, Buildings Manager at Dia, did an excellent job under pressures of time and budget.

Because of the importance of bringing the entire series of "Amerika" paintings together for this exhibition, on view to the public for a nine-month period, we are particularly grateful to the lenders of these works and those helping to coordinate the loans, including Stacey Gershon and Manuel Gonzalez of the Chase Manhattan Bank Art Program; Collection First Bank System, Inc., Minneapolis; Drs. Vijak Mahdavi and Bernardo Nadal-Ginard; Martha T. Mayberry and Charles Mo at the Mint Museum of Art; Kirk Varnedoe, Cora Rosevear, and Lori

Schafer at The Museum of Modern Art; Paul and Camille Oliver-Hoffmann; Andrew Ong; Anne d'Harnoncourt, Ann Temkin, and Nancy Quaile at the Philadelphia Museum of Art; Clay Rolader and Virginia Wright; Julia Ernst and Charles Saatchi at the Saatchi Collection; and Robert and Susan Sosnick. Jay Gorney, Holly Hughes and Caroline Roland-Levy at Jay Gorney Modern Art Gallery; Karen Kelly at the Art & Knowledge Workshop; Rhona Hoffman; and Jerry Saltz provided invaluable assistance during the organization of the exhibition.

This book reflects the efforts of many. The thoughtful essays by Arthur Danto and Michele Wallace are deeply appreciated. Tim Rollins's preparation of notes for an annotated checklist of the "Amerika" paintings is at the core of this book and provides essential information to viewers interested in the "Amerika" series and the work of Tim Rollins + K.O.S. more generally. We are very grateful to Maud Lavin for her assistance in editing the texts in this book. We also thank Jean Foos and Jill Korostoff for their design work and close consultation with Tim Rollins during the book's production.

Generous support for the exhibition and this book has come from the Cowles Charitable Trust, The Emily and Jerry Spiegel Family Foundation, the National Endowment for the Arts, a federal agency, Washington, D.C., and the New York State Council on the Arts.

Finally, I would like to thank the Dia staff, particularly Gary Garrels, Director of Programs, who oversaw all phases of the production of this book and the organization of the exhibition, as well as Karen Ramspacher, Programs Assistant, and intern Isabel Stude, for careful work on the entire project.

C.W.

INTRODUCTION

Tim Rollins + K.O.S. (Kids of Survival) first began to consider making a painting based on the Kafka novel *Amerika* in the fall of 1984. Now five years later, thirteen large-scale paintings in the "Amerika" series have been completed; the last of these *Amerika XII* was finished this summer. The "Amerika" series is the largest body of work of Tim Rollins + K.O.S., developed over the longest period of time. It, therefore, seemed appropriate and important to bring to the public a firsthand viewing of these paintings and related drawings, allowing direct appraisal and study. At the same time, this book provides the first complete record of the series, expands a critical context for the work of Rollins + K.O.S. generally and documents the history, thematic concerns, sources, formal decisions, and techniques for the production of these paintings.

This project also comes at a point of change for Tim Rollins + K.O.S. The first long-term members of K.O.S. are now at an age to move out of the group, pursuing other activities or continuing as K.O.S. instructors. In the fall of 1989 several new students are expected to join K.O.S. The first studio at 965 Longwood Avenue in the Longwood Community Center has been outgrown and a search has been started to find more space or larger space. The hope is that any such move will be a transitional one as the Art & Knowledge Workshop, the organizational umbrella for K.O.S., is transformed into The South Bronx Academy of Fine Art. Rollins's goal is to establish, "a free, private school for artistically gifted fourteen- to eighteen-year-olds from our community." This, too, marks a shift for the activities of Rollins + K.O.S. into a more institutionalized setting, and the question of how they will relate to and exist within the structure of the planned Academy remains open. The role this Academy itself may play within the communities of the South Bronx and the other boroughs of New York also is

under consideration and discussion. Thus, the project at the Dia Art Foundation comes at the close of a major stage in the development of both K.O.S. and the Art & Knowledge Workshop.

The work of Tim Rollins + K.O.S. is extraordinary for the complexity of the process out of which the paintings are made. This process includes not only the collaborative methods of the studio work—drawing and painting—but also a combining of influences from these individuals and from multiple cultural and historical sources. The paintings cannot be disengaged from this process but rather are the final product and gauge of it, and the ways in which the process confronts and expresses the tensions of contemporary culture explains, at least in part, I think, the vivid energy, subtlety, and range of the paintings themselves.

With these issues in mind, the Dia Art Foundation commissioned essays for this book from Arthur Danto, Johnsonian Professor of Philosophy at Columbia University, New York, and from Michele Wallace, Assistant Professor of English at the Center for Worker Education and City College of New York. We asked each contributor neither to prepare simply a gloss on the paintings nor to assume the need for a closed argument of evaluation but to consider the work from a critical perspective which would encourage a more probing understanding of both the paintings and the process. Outside of this request, the authors were free to pursue any point of inquiry they felt would be of most value. Tim Rollins was asked to prepare detailed notes on each painting. These are personal and specific, giving a direct account of the background of each painting. Our hope is that together these texts and documentation will open up the complexity and accomplishment of this work to a broad public.

G.G.

AMERIKA

AMERIKA I

1984–85
oil paintstick, acrylic, china marker, and pencil
on book pages on rag paper mounted on canvas
71½" × 177"
Collection of
the Chase Manhattan Bank,
New York

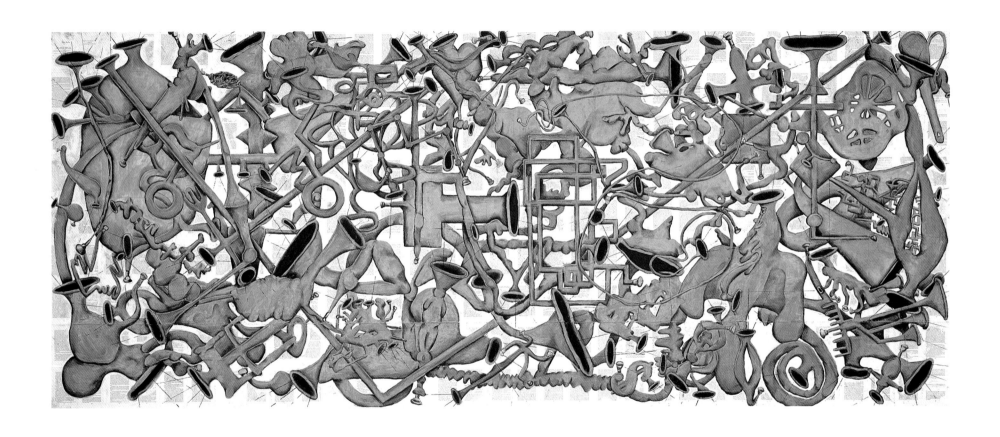

AMERIKA II

1985–86
oil paintstick, acrylic, china marker, and pencil
on book pages on linen
84" × 168"
Saatchi Collection, London

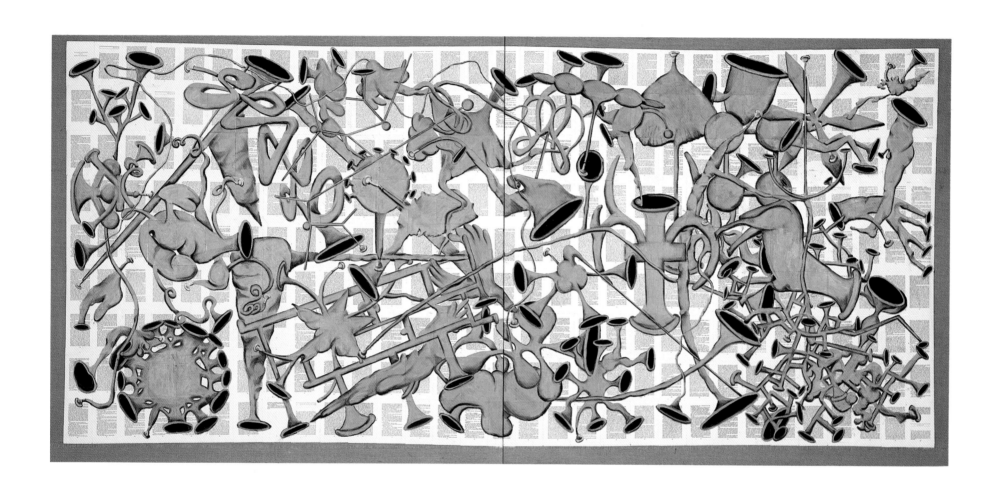

AMERIKA III

1985–86
oil paintstick, china marker, and pencil
on book pages on linen
74" × 164³⁄₄"
The Oliver-Hoffmann Collection,
Chicago

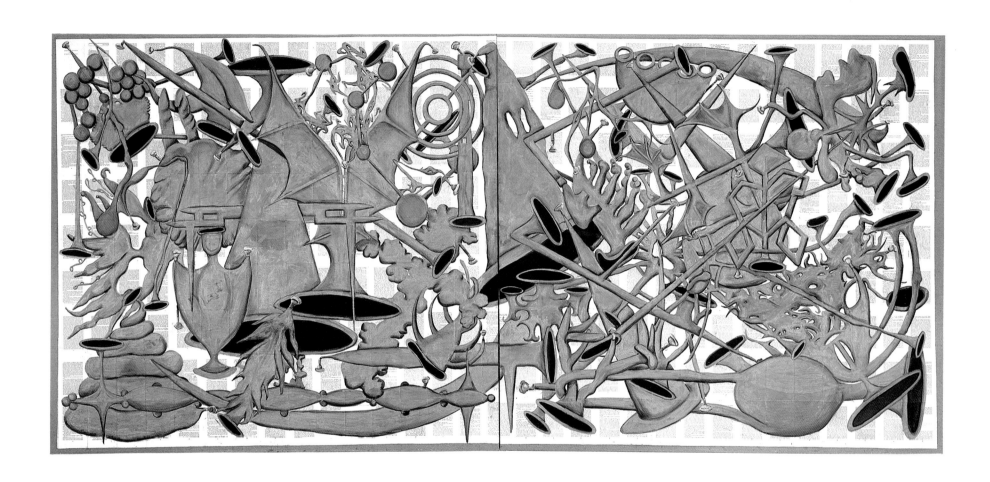

AMERIKA IV

1986
lacquer with metallic powder, oil paintstick, and pencil
on book pages on linen
72" × 180"
Collection of Virginia Wright, New York and
Clay Rolader, Atlanta

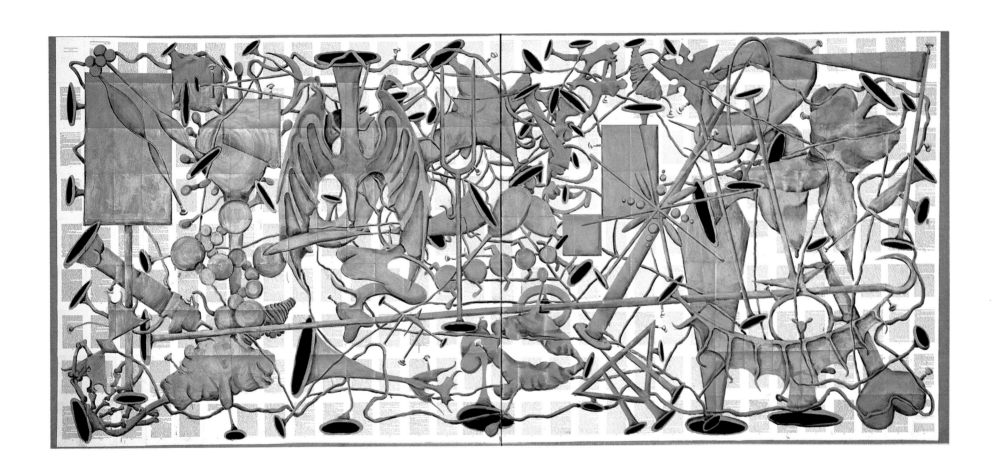

AMERIKA V

1985–86
watercolor, charcoal, acrylic, and pencil
on book pages on linen
66" × 186"
Collection of Andrew Ong, New York

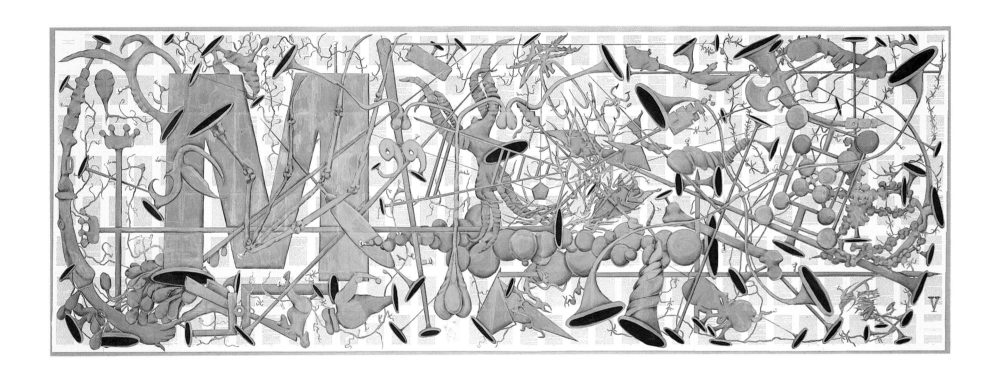

AMERIKA VI

1986–87
watercolor, charcoal, acrylic, and pencil
on book pages on linen
66" × 139"
Saatchi Collection, London

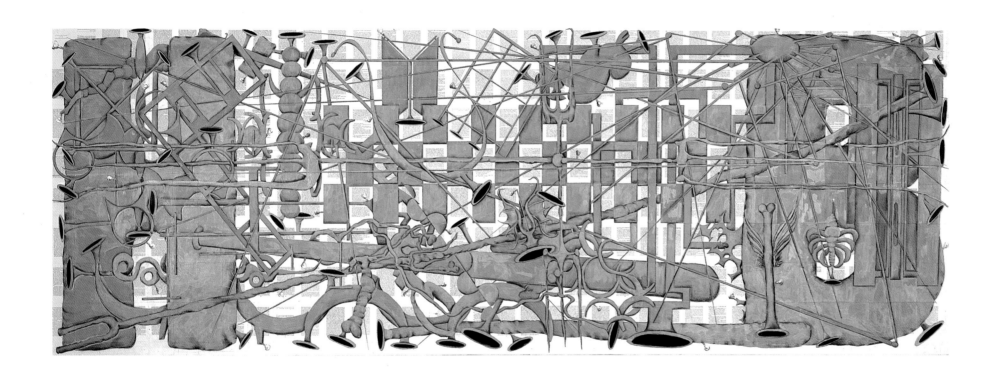

AMERIKA VII

1986–87
watercolor, charcoal, acrylic, and pencil
on book pages on linen
64″ × 169½″
Collection of
The Philadelphia Museum of Art
Purchased with funds
contributed by Marion Stroud Swingle,
Mr. and Mrs. David Pincus,
Mr. and Mrs. Harvey Gushner, and
Mr. and Mrs. Leonard Korman.

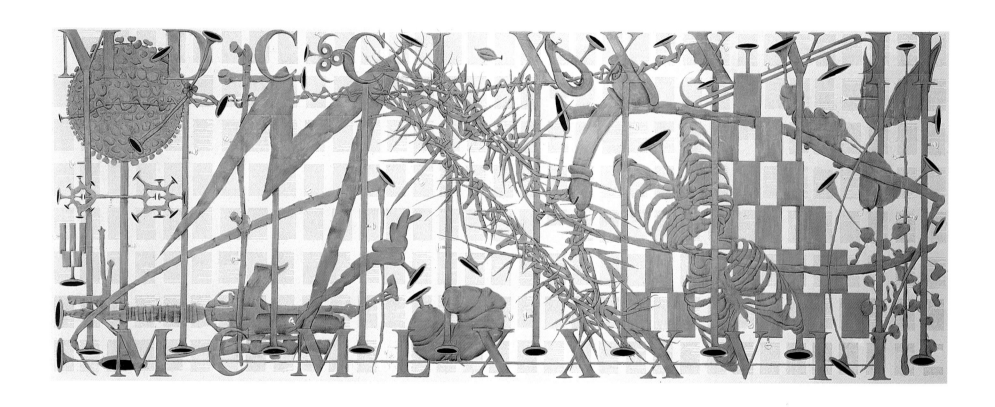

23

AMERIKA VIII

1986–87
watercolor, charcoal, acrylic, and pencil
on book pages on linen
68" × 168"
Collection of
The Museum of Modern Art, New York
Jerry I. Speyer Fund and
Robert and Meryl Meltzer Fund, 1988

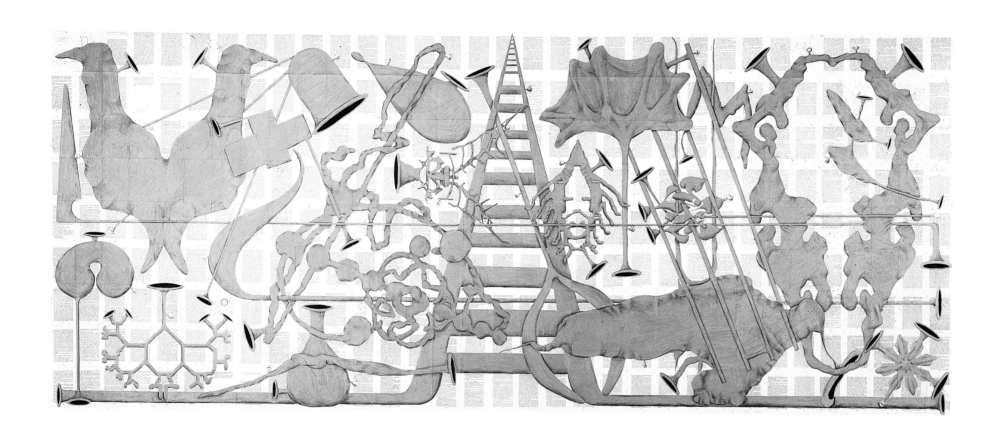

25

AMERIKA IX

1987
watercolor, charcoal, acrylic and pencil
on book pages on linen
64" × 168"
Collection of the Mint Museum of Art,
Charlotte, North Carolina
Gift of the artists and Knight Gallery,
Spirit Square Arts Center,
with support of the North Carolina Arts Council

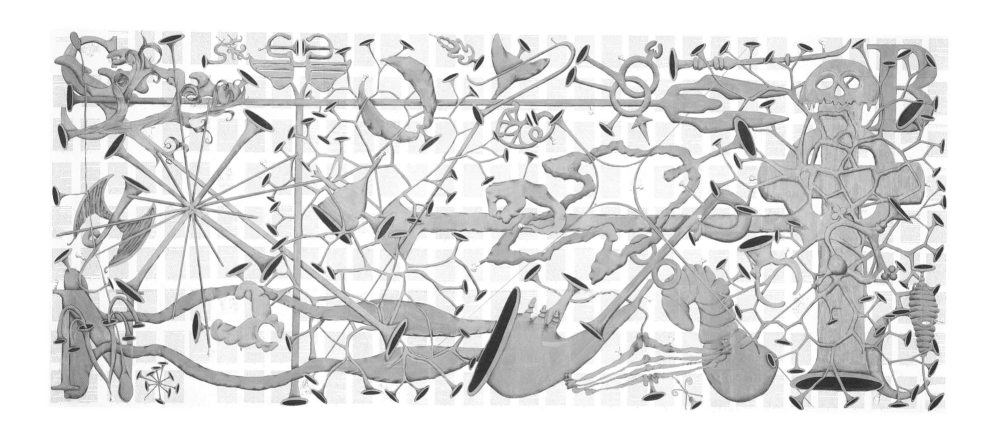

AMERIKA X

1986–88
watercolor, charcoal, bistre, acrylic, and pencil
on book pages on linen
60" × 175"
Collection of Robert and Susan Sosnick,
Detroit

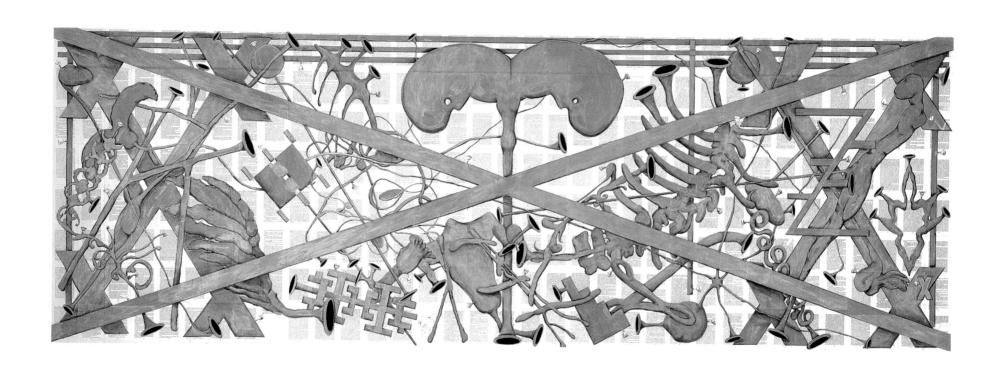

AMERIKA XI

1988
watercolor, charcoal, bistre, acrylic, and pencil
on book pages on linen
68" × 158"
Collection of
First Bank System, Inc.
Minneapolis

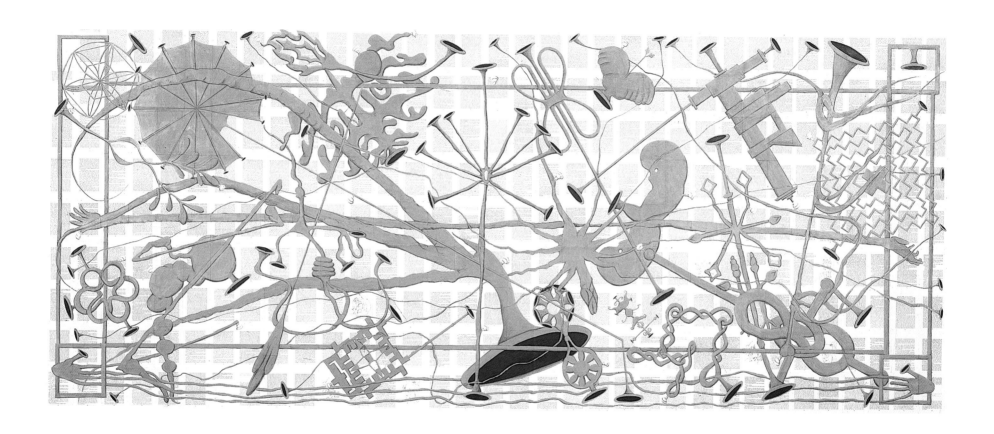

AMERIKA: FOR THOREAU

1987–88
watercolor, charcoal, bistre, acrylic, and pencil
on book pages on linen
60¼" × 175½"
Collection of Vijak Mahdavi
and Bernardo Nadal-Ginard,
Boston

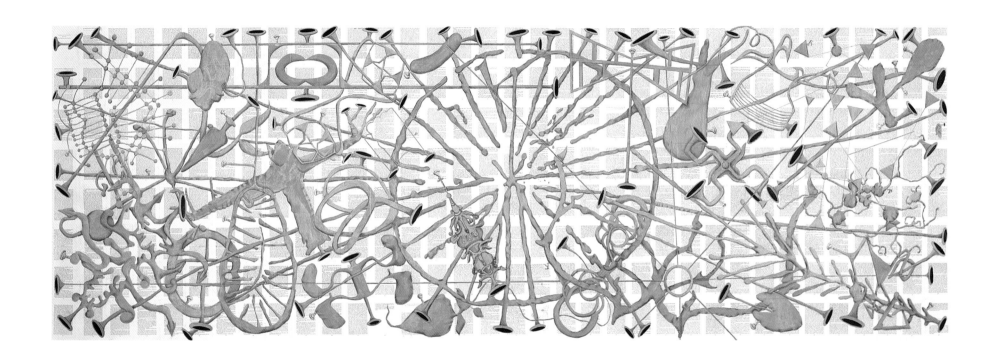

AMERIKA XII

1988–89
watercolor and pencil
on book pages on linen
60" × 180"
Collection of the Art & Knowledge Workshop, Inc.
South Bronx, New York

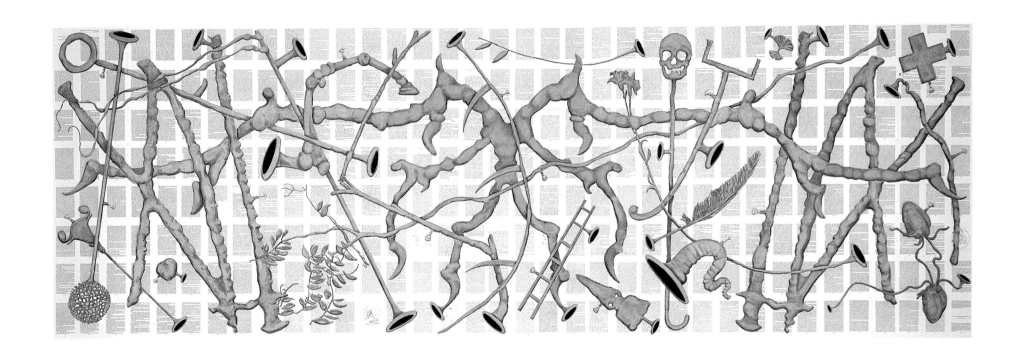

TIM ROLLINS + K.O.S.: THE "AMERIKA" SERIES
MICHELE WALLACE

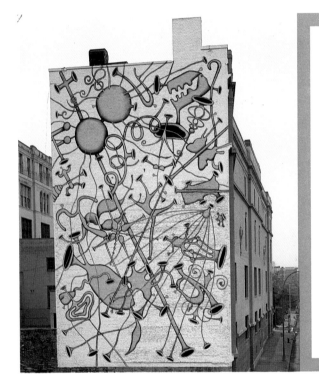

Critical pedagogy is a form of cultural politics.

Henry A. Giroux

For me, art and education are like two sides of the same sheet of paper, separate disciplines and yet indivisible.

Tim Rollins

AMERIKA—*For the People of Bathgate, 1988*
Community Elementary School 4, Bronx, New York

n 1981, Tim Rollins was a 26-year-old white artist from Maine who had studied with Joseph Kosuth at the School of Visual Arts, had co-founded Group Material, an alternative space and advocacy group for socially committed art, and who taught art as part of the special education program at I.S. 52 in the South Bronx. At the time, he made the highly unconventional and radical decision that he would combine his own art-making with the teaching of art to black and Puerto Rican public school children. This decision led to the founding of K.O.S., which stands for Kids of Survival, and the Art & Knowledge Workshop.

Together with a small, evolving group of "learning disabled" and "emotionally handicapped" kids from the South Bronx, Rollins began a process of political art-making which had the dual purpose of educating kids in the South Bronx about the world outside and educating the world outside about the South Bronx. But the real breakthrough in methodology came when Carlito Rivera, one of the kids in the Workshop, drew on one of Tim Rollins's books. "I wanted to kill him at first," Rollins says, "but boy, it looked great. And it was wild because here you have this dyslexic kid who couldn't read a word of the book, but in the drawing on the page—boom! there it was—all in an image. How did this kid know that this was the essence of the book?"

It was a breakthrough precisely because the heartbreaking struggle around literacy and reading was so central to the problem of critical and pedagogical resistance among radical teachers like Rollins and the counter-resistance it inevitably aroused among poor black and Puerto Rican kids in the South Bronx and other urban ghettos. At the heart of the difficulty were the so-called "learning disabled" and "emotionally handicapped" kids Rollins was working with, categories endlessly expanded by the Board of Education in order to accommodate the increasing numbers of children of color considered ineducable. Painting on text—moreover, the classical text of European art and literature—became a way of simultaneously staging a protest against the failure of our educational system as it is conceptualized by the dominant discourse, and de-territorializing the still-remaining instructive vitality of high modernism.

"The making of the work *is* the pedagogy," Rollins explains. "The art is a means to knowledge of the world. That's why our project is so different from regular school—the kids are immersed in production—cultural production." The destruction and the construction of the text are held in a precarious balance as Rollins pays homage to his education (a B.F.A. from the School of Visual Arts and an M.A. in Art Education from New York University) by taking the kids to museums, reading to them from the "classics," and by teaching them the mechanics of art-making; and the kids pay homage to their education in prison-like schools and in the streets of a crack and AIDS-ridden South Bronx by sharing with Rollins their emotional and aesthetic sensitivities. They join forces in their mutual instrumentalization of the text in the realm of the visual. Often the roots of their common understanding of images draws upon the abject in popular culture, for example, in horror movies and monster comic books such as Marvel Comic's *X-Men*. The *X-Men*, which began as a comic book series in the '60's, is about a group of teenage mutants whose deformities give them superpowers to fight evil in the world. Their spiritual and intellectual leader is a bald-headed professor who communicates with them by telepathy.

Although Rollins is nothing like the bald-headed professor in the comic book, the members of K.O.S. like to think of themselves as the X-Men, and *X-Men* comic books are listed first on a Workshop bibliography that "may help you develop a deeper understanding of our work," which K.O.S. distributes during its fairly frequent public appearances on panels. That bibliography

also includes Paulo Freire's *A Pedagogy Of The Oppressed*, Ralph Waldo Emerson's essay on "Self-Reliance", Henry David Thoreau's *Walden*, Deleuze and Guattari's *Kafka–Towards A Minor Literature*, Robert Coles's *Children of Crisis*, George Bataille's *Literature And Evil*, Lionel Trilling's *Beyond Culture*, Dr. Seuss's *The Cat In The Hat*, Tillie Olsen's *Silences*, and *The Autobiography of Malcolm X*.

It is doubtful whether any of the current members of the Workshop besides Rollins, such as Richard Cruz (19), Georges Garces (16), Carlito Rivera (17), Annette Rosado (16), Nelson Montes (17), and Jose Parissi (21) have read these works. Some of the members of K.O.S. are dyslexic, which makes it difficult for them to read. Those members of K.O.S. who can read admit they find it boring. But the object of this exercise is more the critical pedagogical environment which the bibliography, the production of the work, and the process have created. That workshop participants should aspire to intellectual growth is implicit in all their work. If they haven't read the books, the books are there for them to read, and the encouragement is there as well. More to the point, Rollins says, "The work is about survival—survival as individuals, as a group, as a people, a nation, a species. And it's about the survival of the books themselves, literature, language, culture. That's why knowledge is so important, because without knowledge about how the world works and where our ideas and hopes come from, there can be no freedom, there can be no democracy. Knowledge isn't power in itself—it's what you *do* with information that makes a difference. Our art works are teaching machines."

But even more to the point, Rollins embraces the pedagogical philosophy of Paulo Freire, the renowned Brazilian educator, who maintains that progressive and liberatory education is, necessarily, dialogical, by which he means that the dominant model for education should not be a passive transfer of knowledge from teacher to student but rather the active dialogue of teacher and student. Of course, the problem here is that dialogue is the hallmark of the elite, private school education. In contrast, public school education de-emphasizes personal contact and exchange between teachers and students because small classes are too expensive. Also, the pedagogical ideal tends to be authoritarian, perhaps partly in order to make a preference out of a necessity. (A lot of teachers are simply concerned with maintaining "control" in the classroom.) But the gravest obstacle of all to the dialogic, multicultural classroom which confronts even the most radical and committed teacher today (even if that teacher is a person of color) is finding a common language in which dialogue and the production of knowledge can take place. "I don't believe in self-liberation," Freire says in *A Pedagogy for Liberation*. "Liberation is a social act. Liberating education is a social process of illumination. . . . Even when you individually feel yourself most free, if this feeling is not a social feeling, if you are not able to use your recent freedom to help others to be free by transform-

Study Drawing for Amerika XII *watercolor on book page, 7" × 5"*

ing the totality of society, then you are exercising only an individualist attitude towards empowerment or freedom."

Even if the revolutionary austerity of such a program is not entirely appealing, Freire is still making a crucial point here about how one might teach critical literacy, not only to the children of the middle class and children who can already read, but also, crucially, to the increasing numbers of children, particularly children of color, who are being trained and prepared only to linger on the margins of the status quo.

As for the common language in which a dialogue can take place between teacher and students, and not just any dialogue but a dialogue which moves the student towards critical engagement with the text of Western culture, Rollins has come up with a very special answer. "We make art with books, and we turn books into art," Rollins says. In response to which Richard Cruz, one of the Workshop members says, "I guess art is one of the only ways we show our point of view, about how we see the world." "Our paintings are us," Annette Rosado adds, "and we're showing ourselves to people like an open book." Which seems, at least, a beginning.

Ironically, these "teaching machines" have propelled K.O.S. to the tangible art world success of having a dealer in SoHo (Jay Gorney) and having their work included in the collections of The Museum of Modern Art, Charles Saatchi, and The Chase Manhattan Bank. So far the income has gone right back into

K.O.S.'s foundation, which has allowed the Workshop to become independent from the censorship-prone machinations of Federal funds for the arts and from the bureaucracy of the public school system, which would prefer that they emphasize quantity over quality. As is conventional in art education programs, the focus would then be on training good art consumers,

not astute cultural producers. The foundation pays salaries and stipends and underwrites the trips that the Workshop has made around the country and around the world to see and to make art. In the future, Rollins plans to organize The South Bronx Academy of Fine Art—a free, fully accredited, private school for fourteen- to eighteen-year-olds from the South Bronx. But the most impressive form of their success so far has been a critical pedagogical process which daily seeks to transform the lives of Workshop participants as well as the community around it, for it is a model that might be adapted for use in a variety of educational settings.

The first "Amerika" painting I ever saw was *Amerika–For The People Of Bathgate*, 1988 which appears on the wall of Central Elementary School 4 on Bathgate Avenue in the South Bronx. I was in a taxicab with Tim Rollins on a cold Saturday morning in February riding into a desolate neighborhood which is apparently abandoned on the weekends—no people, just that inexorable urban greyness—when we turned the corner of Bathgate Avenue, and there it was looming above us. Right away I had to smile. The painting

made no pretense of being anything but paint; yet a series of golden horns as abstract and wild in variation as characters in Dr. Seuss seemed to be flying about in space, raising a joyous, clattering, anarchic racket in the morning light. I could almost hear it. Moreover, I could not stop wanting to look at it.

The reproductions and transparencies I had seen of the "Amerika" series the week before in Dia's SoHo offices had scarcely prepared me for such pleasure. While they seemed both agreeable and amusing, I must admit that I am no longer easily impressed by paintings. For me, the way the paintings are made and what is to be made of the paintings has to be at least as important as any reading I might have of their intrinsic quality. For "painting" does not merely signify my grandmother's Sunday painting for her own amusement or even my mother's successful painting as a feminist artist, but rather the endless reproductions of Leonardo Da Vinci's *Mona Lisa* which toured the U.S. when I was a child, or Vincent van Gogh's *Sunflowers* which was sold recently for millions of dollars.

Therefore, it seems appropriate to include "the painting" in what Walter Benjamin refers to as "cultural treasures," which he advises us to view with "cautious detachment." His famous statement that "There's no document of civilization which is not at the same time a document of barbarism" can also be interpreted to mean that European high culture not only reconsolidates white dominance of the political and economic spheres, but also repetitively restages the barbarism of the original conquests of imperialism and colonialism by excluding people of color, poor people, and third world people from the production of "cultural treasures." In particular, the individual "painting" executed by the individual "artist" has become a symbol of the intense reification and alienation which plagues and deforms the utopian potential of cultural production in the West. Moreover, the history of fine art in the West seems calculated to render the art of the "other" as the exotic, primitive exception to their usual systematic exclusion. In the art world, white is still right, and the issues of race, class, and cultural diversity are eternally mystified behind the rhetoric of "quality and "standards" and "high culture".

So, it was the process of Tim Rollins + K.O.S., the idea of a multicultural collaboration which would focus as much on the political and cultural transformation of the people involved as on the vagaries of the art market, that attracted me. Accordingly, it was just as well that the first "Amerika" painting I saw was the Bathgate mural, for it is perhaps the consummate public work. So perfectly and subversively discontinuous with its lifeless public space, it gave me a chance to realize that, in fact, the collaborative and inclusive mode of production of Tim Rollins + K.O.S. does make a difference in the end result of the work itself. Not only does the "Amerika" series find its perfect venue, in a sense, on the wall of a South Bronx public school, it is also successful at transforming that space at the level of the visual. As in the live performances of New Music groups like Sun Ra, Ornette Coleman, or the New World Saxophone Quartet, the formal unity of vision we so deeply desire in art had somehow been seduced into a truce with the articulation of diverse "visions" and "voices." I refer to "voices" and "visions" even as "Amerika"'s golden horns seem to be laughing at the possibility of mimesis. The visualization of musical instruments so bizarrely deformed raises the question of music and harmony even as it bypasses the literal response.

The most fascinating thing of all was that it was somehow obvious that more than one person had a hand in *Amerika–For The People Of Bathgate*. An aura of improvisation associated with jazz and ordinarily inconceivable in the concrete and material terms of the visual sphere seemed present as well. "Difference" is held "in a state of balance," Jean Fisher has aptly

said of the "Amerika" paintings, in a "celebration of cultural heterogeneity." I now like to think that just seeing the Bathgate mural would have also given me some inkling of the history of the extraordinary collaborative and pedagogical process employed by Tim Rollins + K.O.S. in the making of the "Amerika" series.

But in addition to the important accomplishments growing out of this collaboration, there are problems for me, as well, with the success story of Tim Rollins + K.O.S., the first and most obvious of these being their name and the fact that of the group only Rollins (because he's white, male, and educated?) has had an individual identity in the art world. The other two difficulties are actually two sides of the same dilemma. On the one hand, there is their critical and irreverent approach to "modernism" and "high culture." This seems to be Rollins's choice stemming from his background in conceptual art, his admiration for the ideas of Joseph Beuys, and his role as co-founder of Group Material. On the other hand, there is their failure to be significantly engaged by multicultural texts or issues.

These form two sides of the same problem because the preoccupation with demonstrating a critical approach to modernism tends to render superfluous and unsophisticated the exploration of various ethnic or even sexual specificities. This conflict has always prevented a white, male, political avant-garde in the arts from becoming seriously and critically engaged by non-white and/or non male, political avant gardes in the arts—especially since not infrequently texts and art by people of color are actively involved in constructing modernist aesthetic and philosophical criteria of their own.

Despite the widespread notion among white scholars and critics that modernism is exclusively high European and, therefore, lily white and, therefore, something that should pass like apartheid, there has emerged among black critics in literary criticism at least (and it seems to me relevant to discussions of black cultural production in music, dance, theatre, and the visual arts as well) a parallel notion of black modernism (or black modernisms). The term modernism is used not in order to periodize but in order to describe sometimes ongoing aspects of cultural production in the Third World and the cultural production of what Gayatri Spivak refers to as "internal colonization" in the so-called First World (which would appear to include almost all "minority" cultural production).

I do not want to get into a discussion here about the features of modernism except to say that they would obviously include some of the most widely held and thoroughly institutionalized values about what art "is" and ought to be in the present. By borrowing the term "modernism" in order to describe some varieties of "minority" art practice, I not only mean to choose this way to name those features that mark intense European or white American influence in black or "minority" cultural production (such as the very concepts of the individual artist, the novel, the painting, or the symphony,) but also to identify where black or minority cultural production has borrowed from "white" modernism in order to reinvent, revise, reclaim, redefine those notions concerning the spiritual and/or ethical value and purpose of art.

I am thinking particularly of the idea of art as transcendent, as in Walter Pater, or the idea that art will cure what ails "civilization," as in Matthew Arnold, even as such ideas are increasingly accompanied by their constant and incessant problematization as in Kafka, T.S. Eliot, James Joyce, Gertrude Stein, and others. This is so much the case that much of modernism inadvertently memorializes the failure of art to transcend the material. But there is also the setting up of a dichotomy between the cynicism and demoralization of realizing

art's failure to cure "civilization" and the notion that some-thing—the "other," "Nature," "the unconscious"—lies beyond both "civilization" and "art" and can, therefore, offer salvation.

Most significantly in the case of modernists like Gauguin or Picasso, it is a "primitive other" which is made to signify the possibility of moving beyond. Of course, we've come to under-stand that such a dichotomy is the raw material of "racism," "neo-imperialism," "neo-colonialism," and the passive-aggressive course of appropriation that has accompanied the rise of transglobal capital. It is perhaps necessary to recog-nize as well that as whites were using such ideology to turn their backs on the cultural production of people of color, artists of color were picking up the pieces, borrowing, re-appropriating that which had been appropriated, constructing a di-alogue with white modernism (one-sided and unheeded by white modernists) and, significantly, a dialogue with a silent, in-articulate "primitive other" whom they saw as their former or their undiscovered selves. The more educated and the more schooled artists of color were in the pre-cepts of European art, the more middle class they were—and they really needed to be both in order to survive—the more likely they were to join white artists in conceptualizing a "primitive other" as un-fathomable, even as they might refer to it as a better, wiser, truer self. As black artists and artists of color, whom I would describe as modernists—Jean Toomer, Langston Hughes, Richard Wright, Ralph Ellison, Zora Neale Hurston, Jacob Lawrence,

Romare Bearden—tried to close the gap between their educated "white" selves and their primitive "black" selves, they were nevertheless, involuntarily or voluntarily, engaged in a re-lentless critique of such unities as the self, the primitive, the natural through their enunciation of how these categories have been used to render blacks "invisible." So to return to my earlier point, if modernism is viewed as a net-work of diverse, heterogeneous, and still open-ended approaches to the problem of cultural progress, then it becomes pos-sible to talk not only about European modernism in the past, but also the use of modernist strategies (among others) by emergent global cultures of the Third World, as well as minority cultures in the "First World."

The relevance of all of this to Tim Rollins + K.O.S. involves only specula-tion on my part, since what they're doing doesn't really fit any of the familiar cate-gories. It seems to me quite clear that while Rollins's own inclinations as an art-ist would generally place him among postmodern strategists, he has often re-marked that his relationship to K.O.S. has been pulling him towards a reevalua-tion of modernism and modernist strat-egies such as abstract painting. My theory is quite simply that aspects of modernism—for instance, Picasso's *Guernica* or Georgia O'Keeffe's Southwest—make more sense to the young artists of color in K.O.S. than they do to Rollins, and as such, they are moving him towards their practice. I want to emphasize that by this I do not mean that they are coming up with a rehash

of obsolete, white modernist strategies, but rather that Rollins is engaged with them, perhaps somewhat unknowingly, in the formulation of yet another multicultural strain of modernism. It is more streetwise, democratic, and inclusive than the old "white" modernism; it is less naive and/or "ethnic" than the old "black" modernisms; yet, at the same time it is more utopian and hopeful than any kind of postmodernism heretofore. It is doing in art something like what you might get in dance if you crossbred the Alvin Ailey Dance Company with Pina Bausch.

But the problem of the absence of multiculturalism at the level of content remains. When asked why K.O.S. doesn't read Toni Morrison's *Song of Solomon*, Rollins is dismissive. "We're too close to it," he'll say, or, "We prefer to work with dead art," like Kafka and Flaubert. Novels and paintings are dead forms, so what more fitting tribute to the failure of modernism than painting on a novel? People of color and their deployment of novels and paintings simply don't enter into it.

While it is true that the examination of the work of a black female writer like Morrison does run counter to the critical purpose of the group as defined by Rollins, I can't help but wonder if *Song of Solomon* is really that much more readable to these mostly Puerto Rican teenage boys. My perception in teaching such novels at universities is that even young black girls don't have any special access to Morrison's language. They have to be taught to read her. In particular, they have to be taught to read her critically. But if

morning was a slender, [...]bly [...]le young man, whom Uncle Jacob brought i[...] the room [...]h a string of fulsome compliments. He was [...]iously one [...] these many millionaires' sons who are rega[...]d as fai[...] by their parents' standards and who lead strenu[...]es which an ordinary man could scarcely endure for a sin[...]e average day without breaking down. And as if he knew [...] divined this and faced it as best he could, there was alw[...] about his lips and eyes an unchanging smile of happiness [...]which seemed to embrace himself, anyone he was speaking [...] and the whole world.

With the unconditional [...]roval of Uncle Jacob, it was arranged that this young m[...], whose name was Mr. Mack, should take Karl out riding [...]very morning at half-past five, either in the riding school o[...] the open air. Karl hesitated at first before consenting, sinc[...]e had never sat on a horse and wished first to learn a little [...]ut riding, but as his uncle and Mack insisted so much, a[...]ing that riding was simply a pleasure and a healthy exer[...] and not at all an art, he finally agreed. Of course, that mea[...]that he had now to leave his bed at half-past four every m[...]g, which was often a great hardship to him, since he s[...][...]rom an actual longing for sleep, probably in consequence o[...]he unremitting attention which he had to exercise all day lo[...]; but as soon as he came into his bathroom he ceased to be so[...]for himself. Over the full length and breadth of the bath [...]tched the spray—which of his schoolmates at home, no m[...]ter how rich, had anything equal to it and for his own use a[...]e?—and there Karl could lie outstretched—this bath was [...]e enough to let him spread out his arms—and let the str[...]h of luke-warm, hot, and again luke-warm and finally ic[...]old water pour over any part of him at pleasure, or over h[...] whole body at once. He lay there as if in a still faintly surv[...]ng enjoyment of sleep and loved

45

Morrison is, however, more readable to K.O.S., then wouldn't that make it precisely the text to make reading less "boring"?

Yet a further question remains whether or not there would be the same interest in the art market for a K.O.S. that painted on the text of Toni Morrison or Toni Cade Bambara, or even *The Autobiography of Malcolm X*, as they did at an earlier stage.

Which brings us back to the emphasis in a white art world on a white male Tim Rollins at the head of K.O.S. Isn't it also true that if Rollins were black and a woman and the texts were black or Puerto Rican, with the "kids" being black or Puerto Rican as well, that we would be talking about something much less marketable, something infinitely more obscure?

While the group began its existence in 1982, with a rapid turnover in the kids who made up the group, the first real success came with the first "Amerika" painting done during the school year of 1984-85. Rollins's classroom on the third floor of I.S. 52 was where all the difficult kids congregated when they had nothing else to do. The canvas covered with the pages from Franz Kafka's novel *Amerika* hung in the room for a year. Rollins told the evocative story of Karl and The Nature Theatre of Oklahoma and perhaps forty kids, only one of whom is still in K.O.S., took a serious shot at designing golden horns. "Shots" seems not an entirely metaphorical way of describing what was happening in a classroom in which throwing things was not uncommon. The result was *Amerika I*, first exhibited in "The

State Of The Art: The New Social Commentary" at the Barbara Gladstone Gallery. It was subsequently sold to The Chase Manhattan Bank, and undoubtedly was important in securing for them a National Endowment for the Arts grant. This money was used to pay for a studio of their own to go to after school, the first step towards independence, autonomy, and an art world identity for the Workshop.

Twelve other "Amerikas" would follow. Among these were *Amerika IX, 1987*, a collaboration with kids in Charlotte, North Carolina, *Amerika XI*, 1988, a collaboration with kids in Minneapolis, Minnesota, and *Amerika: for Thoreau*, 1988, a collaboration with teenagers from the Dorchester and Roxbury areas in Boston, Massachussetts. The mural *Amerika–For The People Of Bathgate*, 1988, was made in collaboration with the faculty and students of Central Elementary School 4 in the South Bronx.

Kafka never finished the novel *Amerika*, and he never intended that it should be published, having left instructions with Max Brod, his best friend, to burn all of his manuscripts. Nor did he ever visit the U.S., although it is reported that he thought of Americans as "healthy and optimistic." Yet that isn't the picture Kafka actually paints of Amerika. In the book Karl, the protagonist, forced to leave his native land at sixteen because he had made a servant girl pregnant, comes to Amerika on a boat. A wealthy and powerful uncle appears at the boat to take Karl in. After a brief period of language instruction and horseback riding lessons, he is rather

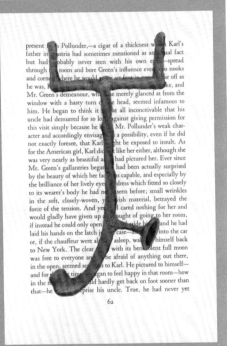

arbitrarily disinherited for disobeying the uncle's advice. Karl then embarks on a series of adventures during which he encounters a variety of unscrupulous characters, all of whom take advantage of his youth and his lack of family in order to exploit and abuse him. Nevertheless, the novel ends on an upbeat note with a gap in the text and then the final chapter called "The Nature Theatre of Oklahoma."

It is this chapter which concerns Tim Rollins + K.O.S. Rollins narrates the story: "At the end of the year, he's ready to go home. He says to himself, 'I can't handle it, I'm a failure, I can't make it in Amerika.' And so just as he's about ready to get back on the boat and go home, he hears this sound. It sounds like a Salvation Army band. They're all carrying these placards. And the placards say, 'Come join the Nature Theatre of Oklahoma! The Nature Theatre of Oklahoma where anyone can be an artist and everyone is welcome!' And Karl looks at this and thinks, 'I have been lied to, I have been cheated, I have been robbed, and I am sure this is just another situation where I'm going to get ripped off. But then again, that one sign says 'Everyone is welcome.' Even if it is bullshit, I'm going to try it. I've never seen that in Amerika before.' So he joins.

"Then they say, 'Well, we're leaving for Clayton tonight on a train. We're all going to go at midnight so you've got to get registered at the race track. You have to register before midnight because that's when the train goes, and you lose your chance

forever.' So he goes to the racetrack, and as he approaches the racetrack, he hears this incredible sound of a traffic jam, and it's hundreds of horns like a jazz orchestra or something. And as he walks into the racetrack he sees an incredible scene of hundreds of people standing on pedestals, dressed up like angels blowing whatever they want to on these long golden horns. There's a big fat person who's making little noises, and a little skinny person making big noises, and it's this big kind of mess. All these sounds together.

"And Karl asks the old man who brings him in, 'What is this?' and the guy says, 'This is Amerika where everyone has a voice and everyone can say what they want.' That's it. Then I say, 'Now look, you all have your own taste and you have different voices. If you could be a golden instrument, if you could play a song of your freedom and dignity and your future and everything you feel about Amerika and this country, what would your horn look like?'"

The process for Tim Rollins + K.O.S. is a lengthy one, sometimes a year and often much longer. When making an "Amerika" painting—or any of their other projects such as the "Temptations of St. Anthony" series, or "The Red Badge of Courage" series in which they painted wounds, or "The Scarlet Letter" series in which they made elaborate calligraphic "A"s–K.O.S. will select and study the relevant works of other artists in museums and in art books, and images from popular culture. They will do thousands of drawings, which they call "jamming." Then they'll

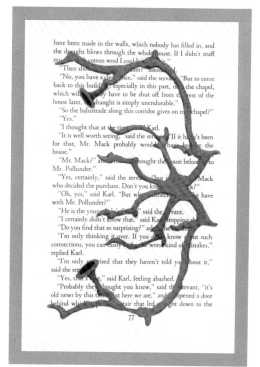

begin to do painted studies on individual pages of the text itself. They sometimes do a large painting as a study. Only at the end of this process is the full-scale work made.

In the case of the "Amerika" series, the variety of horns that have emerged has been simply stupendous–from letters to body parts to animals to piles of shit, floating sperm, baseball bats, and animals—yet none of the images engage in direct representation. Everything looks a little like something but not quite enough to call it that. The group has drawn its inspiration from a wide variety of sources: Marcel Duchamp, Francisco Goya, Grünewald, Georgia O'Keeffe, Picasso, Miro, Paul Klee, William Morris, Uccello, African and Native American art, Dr. Seuss, medical textbooks, comic books, and newspapers, just to name a few. Perhaps the most successful painting in the series that unites their political concerns with the visual effect has been *Amerika VI*, which was done as a memorial to the racial incident at Howard Beach. All of the paintings share a compelling and sophisticated beauty.

For me, however, a bittersweet note in all of this is the idea of Oklahoma being the home of the Nature Theatre where anybody can be an artist. Kafka could have scarcely had any idea of what the real Oklahoma was like as the final destination to which the so-called "Five Civilized Tribes" of the Southeast were driven in a series of forced marches called "The Trail of Tears." Yet his vision of the Nature Theatre seems to bear traces of foreboding as well as utopian hopefulness.

Not surprisingly, these traces of foreboding appear in particular in two details of the story which are often overlooked. First, the hundreds of angels with horns are not just people but "women" on pedestals and, second, Karl calls himself "Negro" when he signs up for work at the Nature Theatre in a typically Kafkaesque scene in which it is repeatedly insisted that "Negro" could not be his real name, although no one says why. Few Americans have any idea of Oklahoma in history or in the present except that it's the place they never want to go. Perhaps because of the fame of the musical *Oklahoma*, today's urban dwellers think of Oklahoma as the home of rednecks and oilmen. But, in fact, after the Civil War blacks thought of it as the land of opportunity, and there was talk of it being designated a black state or a Native American state around the time that it entered the union. Now black and Puerto Rican kids in the South Bronx, who can read neither Kafka nor the history of Oklahoma (although they can imagine both), are painting golden horns on the pages of a German novel which invokes the name of Oklahoma in the spirit of hope, freedom, democracy, and art. Only, as the children of neo-imperialism, they know there isn't any frontier, and they'll have to invent their own.

Garvey, 1985.) The quotes from Walter Benjamin are from the essay "Theses on the Philosophy of History" in *Illuminations* (New York: Schocken Books, 1968). The discussion of modernism in relationship to "minority" and "Third World" cultural production draws indirectly from Henry Louis Gates' notion of "critical signification" described in *Figures in Black: Words, Signs, and the 'Racial Self'* (New York: Oxford University Press, 1987), Houston Baker's attempt to describe black cultural production in terms of modernism without relying upon a notion of influence in *Modernism and The Harlem Renaissance* (Chicago: University of Chicago, 1987) and Gayatri Spivak's notion of the difficulty of subaltern speech in "Can The Subaltern Speak?" *Wedge: The Imperialism of Representation/The Representation of Imperialism*, 7/8: Winter:Spring, 1985 and the problem of "internal colonization" and a postcolonial elite in "Who Claims Alterity?" in *Remaking History*, Barbara Kruger and Phil Mariani, eds., Dia Art Foundation (Seattle: Bay Press, 1989). Also, I must acknowledge some debt to Frederic Jameson's much maligned essay on the frequency of political allegory in Third World narratives, "Third World Literature in the Era of Multinational Capitalism," *Social Text*, 15: Fall 1986; as well as to the demystifying response of Aijaz Ahmad, "Jameson's Rhetoric of Otherness and the 'National Allegory'," *Social Text*, 17: Fall, 1987. Hal Foster's seminal essay "The 'Primitive' Unconscious of Modern Art, or White Skin Black Masks" remains a crucial text and is included in *Recodings: Art, Spectacle, Cultural Politics* (Seattle: Bay Press, 1985).

Sources

The quotes from Tim Rollins + K.O.S. are from an exhibition catalogue published by Riverside Studios, London, a forthcoming interview in *Flash Art*, October, 1989, by Joshua Decter, as well as interviews I've conducted with them in their studio. The ideas on critical literacy and the dialogic classroom come from Ira Schor and Paulo Freire, *A Pedagogy For Liberation: Dialogues on Transforming Education* (South Hadley, Mass.: Bergin & Garvey, 1987); Henry A. Giroux, *Schooling And The Struggle For Public Life: Critical Pedagogy in The Modern Age* (Minneapolis: University of Minnesota Press, 1988) and Stanley Aronowitz and Henry A. Giroux, *Education Under Siege: The Conservative, Liberal and Radical Debate Over Schooling* (South Hadley, Mass.: Bergin &

K.O.S. AND THE ART HISTORY OF COLLABORATION
ARTHUR C. DANTO

He really is putting all his effort into us and we're putting all our effort into him. He's giving us something and we're giving him something. We understand each other.

Carlito Rivera

It's very important to us to make beautiful things.

Tim Rollins

There is a pretty moment in the annals of Pre-Raphaelite art, in which William Holman Hunt and John Everett Millais, young and obscure artists working side by side in a shared studio, painted bits of one another's paintings. Millais had gotten bored with painting drapery in his *Cymon and Iphigenia* and offered to do a head in Hunt's *Eve of Saint Agnes* in exchange for help with folds. Mingling touches has an almost ritual aura, like pooling two bloods in a ceremony of brotherhood or touching lips as the symbol of becoming one flesh in the marriage rite. Though the interchange may have been casual, it implied a certain trust and esteem and went with a form of intense friendship not uncommon in Victorian times, but no longer part of the standard repertoire of emotional relationships. It comes with the sense of a destiny fulfilled that the concept of brotherhood should have become explicit at the end of a summer that began with this affecting swap, when the Pre-Raphaelite Brotherhood became a moral and aesthetic reality. Pre-Raphaelitism was more than a shared style, more than a movement in the prehistory of modernism: it was the ideal projection of a form of life in which the brothers were to be bound to one another in special ways and in which the production of works of art was to be only one component.

Something like this is true of the Art & Knowledge Workshop and the subsidiary entity "Tim Rollins + K.O.S." today, but the differences between it and its nineteenth-century predecessor

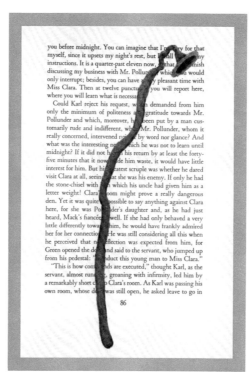

are illuminating and profound. The Pre-Raphaelites did not appreciate the degree to which they would have to invent the kind of life to which they aspired. Instead, they merely sentimentalized forms that had existed in earlier periods of artistic production—the workshop, the craft-guild, the monastic order—none of which could easily have been realized in the industrial and commercial reality of their age, though one of them, William Morris, did undertake a revival of handicraft that was something of a success. Yet even Morris felt a contradiction between his socialist ideals and the sad truth that he was "upholsterer to the prosperous," and his fabrics, as did the paintings of his friends, represented the kind of life it was no longer possible to live without extreme affectation. There is a certain organic unity in an era which rejects, as the body rejects an alien organ, forms of life that functioned in a natural way in an earlier era—as Cervantes demonstrated with his comically displaced knight errant.

But "Tim Rollins + K.O.S." designates a collaborative artistic undertaking based on no historical paradigm, the form of whose existence is as much a product of artistic invention as are the artworks it brings into being through its mode of collaborative creation. The two—social structure and work of art—are internally related in such a way that we must appreciate the works aesthetically in the light of our knowledge of how they have been arrived at, so that both mode and object of production are dimensions of a single complex. Of course, the products, as

works of art, are detachable: they are sold, collected, reviewed, and exhibited just as are works by individual artists working in isolation. Perhaps the form of collaboration could itself be detached and used for ends other than the making of art. But ideally the art and the mode of its making are sufficiently interdefined that we best understand the works by understanding the complex decisions through which they came into being.

"K.O.S." itself—Kids of Survival, a name suggested by the students—designates a group of young persons from the South Bronx, and art-making is a form of mutual education through which each member evolves as the works on which they collaborate evolve. Together they read certain texts, and together they decide how these texts are to be transformed from words into images. Initially, the images proceed from their individual inventions, but which images finally are chosen to embody the text is a matter of slow consensus. And so is the ultimate form in which images transcribed onto acetate sheets and projected onto panels are orchestrated into wholes. Each work sustains a movement from the common experience to individual experiences back to common experience again, this time drawing on what has emerged through the creativity of each participant. Nothing like this order of participatory creation was thinkable for the Pre-Raphaelites, whose imaginations were limited by their times, and who drew their ideal of communality from distant, unusable paradigms.

A wrench of almost anthropological imagination is required to bracket together the Pre-Raphaelite Brotherhood with the Kids of Survival under a single concept. Hunt and Millais, though they knew early struggles, came from supportive middle-class families; they were secure in their conceptions of high culture and moral truth; and their feet were firmly placed on the ladder of access to artistic fame and fortune. They were cultivated, literate men with refined tastes and sensibilities, inter-

ested in philosophy and poetry and history. They had ample studios, and it is possible to imagine them in velour smocks and berets, with flowing romantic scarves. The K.O.S. come from the most dispossessed strata in our society. The milieu of these black and Hispanic youth is the South Bronx, a synonym for a world of violence and decay, poverty and hopelessness, crime and drugs; a culture of video games, rap music, and comic books. The Art & Knowledge Workshop is bounded by this difficult world on one side, and the world of high art on the other, and it is unique because of its boundaries. By its means, the Kids have been enabled to effect a transit from one territory to the other. The Workshop is a kind of schoolroom, with the difference that it is filled with books and artworks of a kind not encountered in schoolrooms anywhere, and that its products are both works of high art and the individuals who collaborate in their creation. It is an environment in which they are given a sense of genuine high culture—its literature, its sense of history, and its sense of what it means to engage with and understand the human spirit. The distance between their lives, as they would have been but for the Workshop, and the lives of the Pre-Raphaelite artists, even if the Brotherhood had never been formed, is immeasurably vast. And even with the Workshop, there is a question of whether it could have been traversed without the collaborative form interaction and creation take.

Neither of those two paintings by Hunt and Millais noted before can truly be construed as collaborations, despite the mingled touches. And neither, I think, can the Brotherhood itself be counted a truly collaborative movement. The members were too caught up with themselves, too ambitious as individuals, too bent on careers and marriages and big Victorian families, actually to *live* the form of life the rhetoric of brotherhood implies, even as artists. Something in the art world of that time at once prevented the realization of the collaborative ideal, and

at the same time made it a poignant moral vision. Daumier said *Il faut être de son temps*—"One must be of one's own times" (as if it were possible not to be!)—but nothing more clearly reveals our perception of our times than the dreams we have of other times. The Pre-Raphaelites sentimentalized the Middle Ages and the Early Renaissance, as the title they gave themselves implies, and it is as if their historical fantasies expressed certain compensatory wishes as fulfilled. Their actual lives, as successful artists, were the deconstructed reality of their dreams of communion and the deepest order of fellowship. That reality was given its structure through an art world much like our own, if in but nascent form. (Indeed, our art world is very much a creation of the Pre-Raphaelites, who invented the modern gallery, the modern dealer, the modern concept of high prices, and the rest.)

It is not surprising that the dream persists into our own time as a form of artistic community in which equality and fraternity are achieved at the sacrifice of liberty, very much as if the three components of the revolutionary ideal cannot be fused into a coherent single unity. The art worlds of the nineteenth century and our own are flawed by a conceptual schism between individualism and communitarianism, between liberty and fraternity, so to speak, as cotenable political categories. Individualism must, in the nineteenth century, have been so pressing an imperative that an art history of the century could be written in terms of the visionary communitarian ideals that accompanied but rarely penetrated artistic practice. It was an era in which the unrealizable obverse of individual consciousness was a form of existence in which that consciousness was submerged, negated, and transcended in the interest of a higher entity. The Pre-Raphaelite Brotherhood is but an example. The Nazarenes before it, the various utopian artistic communities projected by van Gogh and Gauguin and others after it, are episodes in a history that continues to evolve. Collaboration is much in the air of art today, not only as an ideal but as a reality actively lived, embodied in some of the most interesting art of our times. Tim Rollins + K.O.S. is a shining example of this, but I want to meditate somewhat on the history of the collaborative ideal before I characterize its achievement politically, morally, educationally, and aesthetically. Collaboration between artists need have none of what *it* has. In addition to this history, I want to speculate on what must conceptually be in place before it is possible.

The concept of the artist in the Western tradition is specified by two ideal paradigms that coexist uneasily at best, that of the Master and that of the Genius. Each implies quite different institutional structures, and even when these no longer had room for the Master, the concept of the Artist as Genius trailed with it connotations of the earlier forms. Thus the idea of the masterpiece remains a component in our assessment of art works, even though "masterpiece" cannot any longer mean what it did in the framework defined by the Master. The transition from one paradigm to the other, moreover, was slow enough that for long periods of time both ideals lived, as it were, within the same artistic personality, inevitably made unstable in various ways through the necessarily conflicting imperatives that went with each paradigm. Collaboration meant then different things at different stages of this evolution, and very possibly we are moving into a third stage now, as collaboration is beginning to mean something it could not have meant before. Still, now no more than earlier can transformations in ideas be smooth and orderly, and the new concept of the artist, if indeed one is emerging, will inevitably be destabilized by persisting attributes from earlier concepts of the Artist, themselves bearing traces of yet earlier admixtures.

The concept of the Master subtended an institutional struc-

ture of workshops, craft rules, and the economics of commissioned work. Aside from the production of a "masterpiece," as a form of credential, masters would ordinarily not, for hard economic reasons, produce work on speculation, for sale, as it were, in an open market for collectors. Materials in the first instance would be too costly and the work too labor-intensive to justify that order of risk, were it even to have been thinkable. Collaborations between masters of independent workshops had to have been a standing option, however, when the scale and opulence of commissions taxed the resources of the single workshop and some pooling of labor and material seemed a natural way to claim a share of the profits. Collaboration, in this framework, would not contrast in any interesting way with individual enterprise, but would have been an extension of it. It was only in consequence of commissions exceeding the capabilities of the individual workshop, when the size of the workshop was limited by the number of journeymen a master could predictably support, that collaboration became a strategy of prudence.

To be sure, collaborative execution of the decorative program for a chapel, or of an expensive alterpiece, must have entailed some negotiated adjustment in authority and its prerogatives, and this may have extended to the point where either or both the masters would have to adjust style in order to assure a coherence in the product. Or perhaps I am imposing a retroactive criterion of unity onto a period in which stylistic unity was not a component in

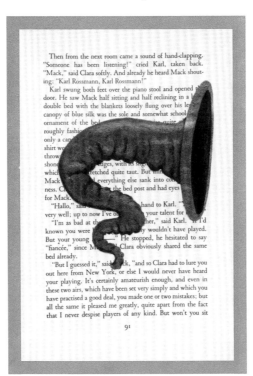

critical appraisal or aesthetic response. The important point is that collaboration of this order involved only external legal agreements, something subject to regulation and enforcement by guilds, like everything else in the world of the Master. And collaboration ended with completion of the work, at which point all mutual obligations had been discharged. Collaboration penetrated no further than that, and in particular it did not penetrate the aesthetics of the work or become part of its content. It is a deeply interesting fact, if it is a fact, that Fra Angelico and Fra Filippo Lippi should have participated in the execution of a famous tondo of the Adoration. It is a matter of high connoisseurship to determine which, if any, of the panels in the Strozzi Chapel are by Orcagna, and which, if any, by Nardo di Cione—and which, if any, by both. But it remains a matter of controversy that belongs to a later period, and another conceptual atmosphere, what difference the truths might make. That these were or may have been collaborations forms no part of what they are about. Collaboration gets to be an artistically important concept when it stops meaning just those issues of external arrangement between artists and begins to affect the way we perceive the representational content of collaborative works: where the works *are* the products of the different artistic presences that gave rise to them, or their deliberate suppression or erasure.

External collaboration is really just a form of division of labor, and to some degree the Pre-Raphaelites were capable of

this. Thus Morris designed and published through his Kelmscott Press a book of Chaucer's poetry with illustrations by Burne-Jones. Both were very famous men when this took place, but they also were friends, and it is truly touching that Burne-Jones put aside his other work to make the illustrations because his friend was dying. So it was more than a business relationship. Both men saw the book as the fulfillment of their youthful fraternal ideals, but in fact it was possible only because they were not brothers but rich and famous artists who happened to share a history of friendship. And they could collaborate only because text and illustrations are separable and separate. I want to suggest that collaboration in the fuller sense exemplified in Tim Rollins + K.O.S., in which works are produced communally on a regular basis, was not available to them conceptually.

Collaboration, except as a neo-medieval revival, ceased being a practical option when the system defined by workshops and masters gave way to a different economic structure altogether, in which artists made paintings without advance knowledge of whether or by whom they would be bought. But this new system was reinforced by a set of moral ideals that went together with the paradigm of the artistic Genius. The work was not to be a negotiated product between a certified master and a patron, where the latter specified what was wanted and the former attached prices and schedules of what was possible within those prices. It was, rather, something that must, in order to be valid

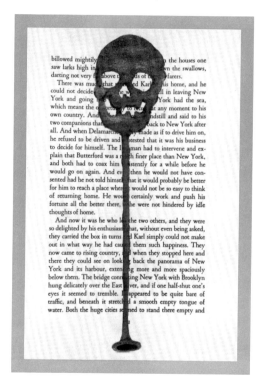

as art, issue spontaneously forth from the creative soul of the artist, as if a force of nature. It became mythically imperative that art arise irrepressibly from the logic of the lonely being of the artist, and it became an ancillary myth that the artist might, even must, go unrecognized in his lifetime and die surrounded by his unsold masterpieces (a myth fulfilled in the exemplary case of van Gogh). This would have been unintelligible under the earlier system. But collaboration, with its chafing restrictions, becomes unintelligible under the new system. The myth rules out compromise.

The Abstract Expressionist Norman Bluhm told me that he simply ended a friendship with another artist when the latter agreed to modify a red that a buyer found too strident. Needless to say, patrons came to internalize the system and *expected* to have their taste flouted and abused, expected to be shocked and even insulted: these would stand as confirmation of the authenticity of the work, just as negative, vociferous critical hostility would confirm the originary artistic vision. It is little appreciated to what degree the negative art critic is, through that negativity, co-opted by the system the critic often inveighs against: the damning criticism becomes part of the system defined by the Genius, since an argument is implied that had the artist been intent on success, he would have made work more ingratiating, and the harsh criticism is proof that he instead was true to his originality. I know a critic so negative that he is celebrated as incorruptible by the magazine

that prints his work. But there is a corruption of negativity, which does more to promote what it vilifies than any amount of favorable criticism possibly could.

Metaphysical originality—artistic creation as if it were *ex nihilo*—defines the modern form of art historical scholarship focused on the individual artist and his or her influence, the latter as a further extension of originality; an artist's traces in the work of later artists becomes as urgently sought as a signature is. So it would be inevitable that strategies of the sort developed by Morelli should serve as prismatic lenses for reexamining works executed when collaboration was an acceptable option, in order to be able to say which parts of which collaborative works were by which artist—as if touch could exist alongside touch, but touches could never meld into one. Earlier, perhaps, it would have been important that a work be by Orcagna for the same reason it would be important that it contain gold leaf or lapus lazuli—evidence that no expense had been spared, as much to impress the saint to whom the work was dedicated as anyone else. But, except for compensation, it would have mattered otherwise very little who did which panel in which predella.

It cannot be overestimated to what degree these preoccupations color the way we address art, even art of a period when none of them had emerged. Thus we look for stylistic discontinuities in order to ascribe them to distinct artistic hands. Scholars cite the unexplained sweetness of Christ's face in Masaccio's *The Tribute Money* as evidence that it must be by Masolino, as Masaccio's faces are more rugged and, well, masculine. (This is countered by those for whom the sweetness is iconographic, Christ's face having to look different from those that surround him.) And think of how numb we feel, how blank, before traditions where the work is anonymous, as if we did not know how to respond when there are no signatures. Or how

latter-day representatives from such traditions begin to adopt the signature and our structures of art history in order to deal with our sort of market!

There is another aspect, aesthetic and economic, of the idea of artistic production dominated by the concept of the Genius. It is difficult to achieve conspicuous originality when one's work conforms to standards largely invariant across the art world—that, rather, goes with the concept of the Master. Accordingly, it is striking that the nineteenth century was so fertile in theories and programs of art, as if creativity entailed not merely works of breathless originality, but whole new concepts of style, whole new theories of art, which entailed that one's competitors, in working under different principles, were not really artists at all but only appeared to be so. Pre-Raphaelite artists demonstrated this tiresome feature of modernity, virtually disqualifying as genuine everything between themselves and Raphael. In their view, articulated for them by Ruskin, art since Raphael was visually false—and it was an easy transition from falsehood to inauthenticity. They had gotten art back on track after three centuries of languishing. At the level of idea, it may be said that the Pre-Raphaelites were brothers, as their theories were the product of intense discussions between them. But collaboration as artists was systematically excluded by the individualistic premises of the art world in which they struggled.

The concept of originality cannot be understood solely as a matter of novelty or as a matter of demonic virtuosity. Rather, I think, the transition from Master to Genius occurred when the artist began to be perceived as a kind of prophet, a medium through which things were disclosed or divulged that might otherwise never have been learned. It is something of this that Kant has in mind in his marvelous discussion of genius as that through which "Nature gives the rule to art." Through the art of

the Genius we learn the rules of Nature. The concept of creativity gradually degenerated into something else, far less exalted than the revelatory role that first belonged to it: it became a kind of bohemianism where the artist because of his genius lived according to his own rules, as the work of art in turn came to be something that existed for itself and in its own right. But the idea of art disclosing truth—rather than standing as a self-referential structure of formalist relationships, as modernist criticism requires it to be—was one of the driving themes of the Pre-Raphaelite Brotherhood. Its charge against the academies was that they taught falsehood, while the Pre-Raphaelites, in contrast, studied nature closely in order to express visual truth in their paintings. Millais's *Christ in the House of His Parents*, exceedingly artificial as it appears to us, was meant to convey to its viewers what real concern looked like on real faces, amidst visually convincing shavings in Joseph's carpenter shop.

I am stressing this ambition of veridicality in order to emphasize its moral character. The Pre-Raphaelites regarded visual falsehood as a form of mendacity. The true contrasts not only with the false; it contrasts, as the truth, with the *lie*. But a lie is something intended to deceive and hence is subject to moral condemnation. They saw themselves as shunning falsehood, not like cameras, which simply register visual truth, but as *honest persons*: a camera is not honest as it cannot lie. And so they saw their program as the moral rehabilitation of art. In this once more they were in agreement with Ruskin, who again did not distinguish truth from honesty, so that the well-made picture stands as an exemplar of moral rectitude, and as such a means for the transformation of society. They were not merely concerned to produce marvelous art, for they ascribed a moral mission to art in bringing about a just society. Good art goes with good men and women and thence with a good society. So

the change they stood for in art was never merely that: it was meant to go with a change in the form of life men and women were to live. It is this moral, transformative dimension of art, axiomatic in the practice of art down to the threshold of modernism when it was very largely dissipated, which is being reasserted in the postmodern era where collaboration itself carries the promise of a certain transformative function.

Collaboration is not, as a form of association, moral as such, as our example of collaborating masters shows. Rival criminal gangs can pool resources when a given heist is too much for their individual capacities, and "collaborator" has taken on an unsavory meaning since World War II. But it takes on a moral rather than a merely legal or negotiable coloration when it defines a form of life itself regarded as moral. Brotherhood—fraternity—implies a relationship in which each member is bound to each member by love and duty and where each is expected to curb his individual interest in order that the totality shall prevail. Something like this was implicit in the spontaneous adoption of the fraternal ideal by the Pre-Raphaelites, who must have been moved to exercise their moral imagination that way through the profound moralization they assigned to artistic representation. It would be inconsistent for someone to insist on imposing a moral criterion on artistic acceptability and at the same time be indifferent to conduct outside the studio. Consistency would require such artists to exhibit in their lives what they celebrated in their art. Even if they could not live up to the ideal of brotherhood, it is important that for them art-making was perceived as part of a single complex that reached beyond the boundaries of art itself. To be a Pre-Raphaelite was like taking a vow. Small wonder their paintings are filled with persons meant to exemplify moral beauty, living in conformity with the highest moral codes.

One might consider their curious predecessors in this regard,

the so-called "Nazarene" artists of Germany. ("Nazarene" was intended as a term of ridicule, as almost always are names of artistic groups and movements—e.g., "Fauve" and "Impressionist" and "Macchiaioli." They called themselves "The Brotherhood of Saint Luke.") The *Lukasbrüder* settled around Rome in 1809, lived in a deconsecrated church, converted to Catholicism, and affected monastic garb, practicing good works as well as undertaking artistic commissions. Indeed, they saw both these latter activities as faces of a single moral-aesthetic impulse, so that art-making was but a part of their form of life. They venerated Fra Angelico and "The School of San Marco" which was mythologized as a group of painter-monks gathered around Fra Angelico in much the same way as the Knights of the Round Table had King Arthur for their moral center. There is, I believe, every reason to suppose that this legend required collaboration between Fra Angelico and Fra Filippo Lippi in the famous mooted tondo, contrary to the stylistic evidence from the body of Filippo Lippi's work. For them then the imagined paradigm of the exalted social order was the monastic order, in which each participant sacrificed his individual identity, bent himself to a discipline of collaborative effort, and received back a new moral identity—almost as though the principles of the order were written by Jean-Jacques Rousseau. This monastic ideal was most particularly celebrated by those philosophical writers of the early 1800's—Wackenroder, Schlegel, Chateaubriand—who

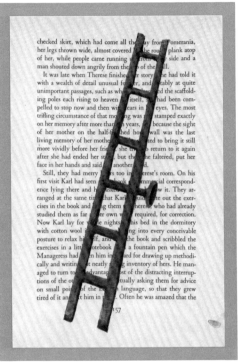

inspired the Nazarenes as Ruskin did the Pre-Raphaelites. These thinkers drew a line between an image, presumed as historical, of a pure Christianity, expressed allegedly in the art of the Trecento and the early Quattrocentro, after which it degenerated into a kind of secular paganism in the Cinquecento and the High Renaissance, when it was no longer possible to live the life of pure devotion in religion or in art. The Nazarenes undertook through an act of social will to return to that presumed innocence, and, like the Pre-Raphaelites, they regarded the entire history of art from Raphael to themselves as one vast degeneration—cynical, meretricious, mendacious. Accordingly, they set about realizing their program on two levels, as monastic brethren and as painters whose works were to express an ideal of moral beauty integral, as they saw it, to their form of life. As an historical curiosity, they venerated Savonarola—he who lit the notorious "bonfire of the vanities"—as a cultural hero who sought to purge and cleanse through fire the kind of painting the Nazarenes deplored. The injunction then would be: paint the way Savonarola would have wished one to, using Fra Angelico as one's model.

The double ideal of the Nazarenes, however, defined a great deal of artistic activity throughout the nineteenth century: to create a form of art that expresses the moral values one should live. It possessed the Pre-Raphaelites, who were, perhaps, too distracted by the appetites of the flesh, too prodded by ambition,

too morally weak, as the ancients would have said, to do more than represent the form of life they could not bring themselves to adopt. It possessed van Gogh who truly had a monastic vocation, and it obsessed Gauguin who certainly did not. Yet Gauguin would not have represented himself merely as a painter: he was transforming art as a form of moral criticism, flaunting the style of the academies and the salons, which were both, as he saw it, inextricably implicated in a civilization he impugned as rotten, since its art was worn out. He insisted on a return to the primitive in two senses and for two reasons: to escape the pernicious values of a debased culture and an exhausted mode of artistic representation. Characteristically, Gauguin envisioned, as so many did, a colony of like-minded artists. And characterstically again, he abandoned his own culture for a mythic one he believed (comically contrary to fact) that he would find in Tahiti.

It is widely appreciated that these visionary forms of life did not and perhaps could not last. They could not because they, finally, were in contradiction to the spirit in which the individuals who aspired to them in fact were required to make art. The paradigm of the solitary Genius, which governed their production and the market for which they painted, made it incoherent to live the life they endorsed. It is striking that throughout this entire period there were no efforts, none at least that I am aware of, to curb individual expression through the discipline of collaboration in art. So they may have been right

that only through changing the way art is made can we change the world. It was only that their individualist way of thinking about how art must be made, which is very much still our very way of thinking of these matters, stood as an internal impediment to the realization of other, more communal social possibilities. Even in the period of their almost incomprehensible mutual creativity, when Braque and Picasso were forging the strategies of Cubism—when they rushed to one another's studios to see what had been achieved that day, when, as Braque said so poetically, they were "roped together like mountaineers" or, as Picasso (in view of his attitude toward women) rather nastily put it, "Braque was *ma femme*"—there was, as far as I know, not a single canvas on which they collaborated.

They did not sign their works, however, so that we might say of any of those works done in the magical years that it is by "Picasso or Braque" even if unable to say which of the two it is by. We could speak of this as a kind of *disjunctive* collaboration. Braque said, "There was a moment when we had difficulty in recognizing which were our own paintings." This in effect meant they had internalized some imperative intended to stultify the individuality up to then regarded as indispensable to artistic expression or to transfer the individuality from Braque to Picasso to the disjunctive entity (Picasso or Braque.) They were explicit about bringing into being a new order of representation that entailed, in a way, a new order of artistic cooperation of the sort into which they fell

spontaneously. Years later, in his discussions of the origins of Cubism with Françoise Gilot, Picasso said: "People didn't understand very well at the time why very often we did not sign our canvases . . . It was because we felt the temptation, the hope, of an anonymous art, not in its expression but in its point of departure. We were trying to set up a new order and it had to express itself through different individuals. Nobody needed to know that it was so-and-so who had done this or that painting." As a disjunction, it was an order that had room for other individuals—Derain or Juan Gris or, as Gertrude Stein called them, the Little Cubists—who might, at the price of anonymity, achieve citizenship in the new order. But again it did not last. As Picasso later said, "We *were* at one time Cubists, but as we drew away from that period, we found that, more than just Cubists, we were individuals dedicated to ourselves. As soon as we saw that the collective adventure was a lost cause, each of us had to find an individual adventure." Braque's individual adventure remained Cubism, under which he found his individual style. Picasso seemed always to be seeking to attach himself to some order or some tradition, as a restless ghost seizes body after body, moving from one to the next, needless to say transforming the host at the cost of his occupancy: think of his possession of Velasquez, Delacroix, Manet—or himself. It was as though for Picasso individuality was a burden his ego prevented him from throwing off.

I have borrowed the term "disjunction" from propositional logic, as I shall borrow the term "conjunction" as well, in order to represent another sort of collaboration. A conjunctive proposition (P and Q) is true only if P is true and Q is true: it is false in every other case. We might then mark off by analogy the *conjunctive collaboration* as one in which something is by (A and B) only if it is by A and by B. Thus a work is by (Gilbert and George) only when by Gilbert and George. (Tim Rollins +

K.O.S.) is itself a conjunctive collaboration, though with a somewhat more complex logical structure than (Gilbert and George). It involves a conjunction between Tim Rollins and a kind of disjunction of members of K.O.S.—Richard Cruz *and/or* Annette Rosado *and/or* Angel Abreu *and/or* Nelson Montes *and/or* Carlito Rivera *and/or* . . . and so on. If Gilbert were to die, that would be the end of (Gilbert and George) if the latter is a collaboration and not a legal fiction like a corporation. But the K.O.S. is fully present even though its membership changes: not every member of K.O.S. is involved in every conjunctive collaboration with Tim Rollins.

The Pre-Raphaelites at best could be a disjunctive collaboration, but in no case a conjunctive one, not even in that episode with which I began, where Millais had a hand in a painting by Hunt, and Hunt a hand in a painting by Millais. But something prevented the works from being by (Millais and Hunt), which means, I think, that the burden of analysis must rest with the notions embodied in being "by"—one of those poetically dense particles of our language in which our deepest perceptions of ourselves and our world are to be found. These are not perceptions that can be captured by logic, and I shall proceed in a somewhat allusive manner to find my way through the "by-ways" of by.

There is a very old meaning of "by" in proto-English, meaning "habitation" or "dwelling place," preserved as a suffix in certain place names such as Derby, or Rugby, or Whitby, or Grimsby. I find it attractive to think of the conjunctive collaboration as the common dwelling place of the collaborators, as if the spirit both of George and Gilbert are dwelling in what we might mark as works that are (Gilbert and George)by. Indeed, we might use it as a suffix for all works so designated—Picassoby, or Veroneseby, as if to mark grammatically the circumstance, mysterious as such things must be, that the

artist dwells in his work, that the "by" does not mark an external relationship between artist and painting, but an internal one. "By" is in common usage a preposition of place, but it implies in general more than a simple geometry of juxtapositions. If I live by the sea, the sea in effect dwells in me: it penetrates my life rather than merely marks where I am located. If I ask someone to stand by me, I do not merely want them to take a position alongside mine: I want them to support me, to not let me down, to *abide* by me. ("Abide" is a verb whose past participle is "abode," which as verbal noun again means dwelling-place, so that "abide by" is almost redundant.) Consider the senses of "abide" in the dictionary: "to stay, to dwell; to wait for; to face or submit to without shirking; to bear patiently, submit to, tolerate." It is a very complex relationship and profoundly human when A and B abide one another, as they must in a collaboration in which something is "by" its constituent members. Finally "by" is that through which something takes place or exists. It is a relationship in which co-dwellers are bound together through moral interconnections in order to bring something into being that presupposes those relationships and is the dwelling-place of those who made it. Millais and Hunt worked side by side, shared a dwelling as a matter of external fact, but there was no work we could designate (Millais and Hunt)by. Yet there are disjunctive dwelling places, so that we may speak of certain works as (Picasso or Braque)by. Something of each member of K.O.S. involved in a given work is in this specific sense mingled with something of every other member of K.O.S. involved in that work, which is a disjoint product of interspersed persons which, as a totality, is a dwelling of mutually abiding artists. One must look to the metaphysics of religious discourse to find something correspondingly complex or exalted, or perhaps to a marriage as construed by a metaphysical poet.

The conjunctive collaboration—as dwelling, mode of togetherness, and efficient cause—is a paradigm of the form of life dreamed of by those great nineteenth-century visionaries too caught up in a set of conflicting institutions to be able to realize it. They may have sought, like the Nazarenes, or again like van Gogh and Gauguin fitfully and briefly in Arles, to have lived such a life. It did not occur to them that it would be possible to live it *in* their art. Just think of Vincent's signature—assertive, unmistakable, not to be overlooked or discounted—and you must instantly appreciate that his painting was *his space*, was finally him, whatever concessions he was prepared to make elsewhere in life.

In his great work, *The Civilization of the Renaissance in Italy*, Jacob Burckhardt writes of the state as a work of art. He meant, of course, the city-state peculiar to that age and place; the modern state is perhaps too unwieldy for the parallels with works of art to have much promise. But the conjunctive collaboration could possibly be thought of as the work of art as state. It is "by" its collaborators in just that sense of "by" to which Lincoln appealed when he spoke of a government "of, for, and by the people." The artists are by one another as mutual abiders when the work is by them as common creators. As this by-one-another-and-by-all is as much political as artistic, we are brought in a natural way to *Amerika*, the text from which Tim Rollins + K.O.S. has developed an ambitious series of drawings and paintings.

The hopeful hero Karl Rossman, of Franz Kafka's hopeful novel *Amerika*, is set down in a country synonymous with hope, the United States of America, where his inextinguishable hope survives betrayal, abandonment, exploitation, cruelty, false accusation, and aggressive stupidity—misfortunes one and all generated by his hopefulness (as the misfortunes of his near-of-fictive kin Billy Budd are consequences of his virtues). Karl

never loses his hope and tries always to be better and to do better—what psychologists designate a "mastery-oriented personality," one who sees in failure the opportunity to improve performance rather than to acquiesce in a view of his own deficiency, as in the case of "helpless-oriented" personalities. Kafka's novels, indeed, characteristically place mastery-oriented personalities in no-win situations in which helplessness is perhaps the only rational response. But America, for all its barriers, its contradictions, and its frustrations, is not the bureaucratic nightmare depicted in *The Castle* or in *The Trial*. It is a land of plausible hope in which Karl (note the K!) is a Kid of Survival. What Karl lacks is knowledge of how things work. What he needs is education. In the end his nearly comical optimism is vindicated when he encounters a structure through which he can fulfill himself in advancing its vast and mysterious intentions. This is the marvelous "Nature Theatre of Oklahoma," a wry and brilliant invention rendered in the book's last chapter.

I can imagine an alternative version of *Amerika* in which Karl comes upon something Kafka would have relished as a name—"The Art & Knowledge Workshop of South Bronx." Only the hopeful need apply. Admitted to it, one becomes an artist. When Karl is asked for his name, he says "Negro." He might as well have said "Nobody," and the moral beauty of the Nature Theater is that every nobody is Somebody. He is issued into a world of golden trumpets and white robes, the attributes

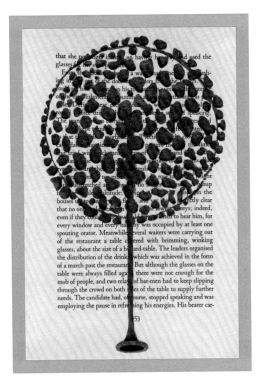

of Heaven. Gold and white are also the colors of Tim Rollins + K.O.S.'s astonishing sequence of panels which do not so much illustrate *Amerika* but constitute a visual equivalent for the feeling it conveys and embody the processes that reflect the political substance of The Nature Theater of Oklahoma and of America in its most ideal form. These works are *based* upon *Amerika* in the double sense of drawing their vision from reflecting upon its spirit and by being drawn *upon*, literally *upon* the very pages of the text. The book is present as matter and spirit.

It was a thought of unqualified brilliance for Tim Rollins to give the members of the Art & Knowledge Workshop this novel to internalize as part of its own history and culture by making it its own through these works. It is the Workshop's task to create a history and culture appropriate to itself as a new society in a renewed land—the South Bronx. Beyond that, it had a task unlike that of any of the collaborations or near-collaborations I have discussed in this essay: to transform its members into artists for the collaboration. Those earlier collaborations, like all other collaborations I know of today, are entered upon by those who already are artists. Perhaps they were already so formed as artists that the collaborations could at best be transient and external relationships between Masters, or Geniuses yielding to one another's autonomy. The difference then is profound between them and the members of K.O.S. The Kids *become* artists through the process of collaboration, which then transforms

those who enter it in ways those already formed cannot expect; so the members and the collaborative grow and evolve together.

The *kind* of artist a Kid becomes must, one supposes, reflect the internal structure of the institution that shapes him or her—the Art & Knowledge Workshop. It might be useful to contrast it with the characteristic workshop of the early Renaissance—say of the sort one would have found in Nuremberg in Dürer's age. The Master was not merely the pinnacle of the workshop hierarchy: he exemplified what everyone in the workshop aspired to become. So the workshop consisted of potential masters at one or another stage of development toward that goal. Each member of the workshop was learning to produce the masterpiece that would earn him the coveted status, a work in which his mastery was exhibited. No one in the workshop need specialize in the various tasks that had to be learned—gilding, preparing surfaces, grinding pigments. The workshop was not a factory, in which the various tasks are distributed at workstations which a worker occupies, doing the same thing over and over in that alienating structure Marx so complained of. Rather, everyone knew how to do everything. However, the master defined the final product, even if he did not always execute it in its entirety, and the final product was a work that was *his*.

I do not see the master-ideal in the K.O.S. Workshop, which has, nevertheless and perhaps inevitably, a certain spontaneous and natural hierarchy determined by the unequal distribution

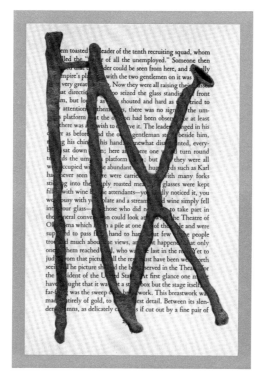

of gifts and degree of practice. Some members, as a simple matter of fact, are better at certain tasks than others and are deferred to in the course of the work—from each according to his or her abilities, so to speak, for the work according to its needs. As everyone consciously participates in the achievement of the work as a whole, there is none of the alienation of an industrial process. I suppose the group must function rather in the manner of a team, where a team is construed as a system of distributed capabilities that some are better equipped to discharge than others: pitchers, catchers, shortstops, and the like. However, everyone can in a way do whatever needs doing.

A Master, greatly enhanced though his powers and productivity be through the workshop, could function on his own, as artists were expected to do when they were regarded as Geniuses. It is in these ways that the kind of artist a Kid becomes through the Workshop is a function of the structure that makes him or her one: he or she is an artist penetrated by the structures of collaboration. What a Kid then would do outside the structure is difficult to say. My sense is that his or her identity could be that of "we," even when alone, rather than "I."

The concept of the collaborative artist is not today uniquely embodied in (Tim Rollins + K.O.S.). There are many collaboratives and collectives in the art world, the difference being again that in most of them the artist was an artist before entering into the collaboration, rather than becoming one through

the collaboration. There is an independent question of why this should have become an attractive artistic ideal today. I am not thinking especially of those cases where both members of an actual marriage participate as collaborators, as in the case of Newton and Helen Harrison, or Arakawa and Madeline Gins, where the collaboration inherits and augments the marriage bond itself. Nor am I thinking of the sibling collaborative of the Starn Twins. (I know of none in which parent and child is involved.) I am thinking, rather, of those for whom collaboration involves not merely the production of art but is an invention of the form of life in which work is made, say as in the case of Fischli and Weiss or Clegg and Guttman. My sense is that it is a form of protest against certain crass values of the art world, a moral option, and accordingly only someone sufficiently immersed in the art world to be disaffected by it is likely to make this powerful shift–almost like entering some order, just as the Nazarenes, who lived in a very different art world, recognized. Yet, while collaboration is a form of protest against the unhealthy glamour of the important name, the rock-star celebrity of the spoiled "hot" artist, it remains the sad truth that such are the constraints of the art world today that the collaborative must in the end establish *its* name if it wishes to succeed, unless, which is a wholly different matter, it intends to turn its back altogether on the art world and its discontents in favor of an alternative utopian existence. And this is not an option for Tim Rollins and the K.O.S., which requires recognition from the art world as a kind of validation.

Part of what stood in the way of Hunt and Millais becoming true collaborators was the need, imposed by their market, to present their work as by individual artists, as products of their genius as individual creators. The market, the structure of connoisseurship, the whole atmosphere of the studio and the life of the artist, pivoted on the signature and everything for which it metaphysically stood. The reverse is true for Tim Rollins + K.O.S. As a distant possibility, one or another of the Kids may become an individual artist, but for the present they enter the art world and the marketplace only as collaborators, only through the corporate logo of "Tim Rollins + K.O.S." The interesting question is what this means for their future as individuals, when their public identity has been as a Kid of Survival? One possibility is that they will go on to become animating centers, like Tim Rollins himself, with art being a means rather than an end, a way of producing certain human types, with the art works themselves as "trophies" (Tim Rollins's expression) picked up along the way. Alongside this visionary perception of a transformed social body, exhibition in accepted galleries under individual signatures seems pretty much moral small potatoes. Tim Rollins + K.O.S. has given a meaning to art that it had lost to mere glamour.

Ours is a time in which all conceptual and institutional aspects of the practice of art, the meaning of "art," and the nature of the artist are being rethought. In my view, this means we are coming to the end of one history and have entered, tentatively, upon another. The existence of active collaborations, rather than collaboration being something merely dreamed of, is evidence of a new attitude and perhaps a new age. I sometimes like to envisage a book, to be written in the distant future, modelled on Vasari's *Lives of the Artists*, though written about groups-as-artists rather than individuals. Part of what I admire about Tim Rollins + K.O.S. is how very much part of our times is this collaboration, rather than undertaking to relive a finally unavailable past. Its model is that of an enlightened school, with a canon and a currriculum and a code of conduct, designed to produce artworks, to be sure, but something more than that–what I have just termed "certain human types"–about which it is, in contrast with the artworks, too early to say very much.

On the other hand—and this is perhaps a paradox—this wider social mission can be fulfilled only if the art produced is of a kind that can hold its own against the sharpest competition from certified artists who enter the art world in recognized or standard ways. The standing miracle is that this has been achieved, certainly in "Amerika", somewhat less spectacularly in "The Scarlet Letter", and to my feeling much less so in "Animal Farm", where the imagery has an obviousness and even crudeness. It is my sense that offshoots of the Art & Knowledge Workshop would be successful only if there were the hovering possibility of works coming out of them of the overwhelming strength and beauty of the great "Amerika" panels. As Tim Rollins + K.O.S. has done this, there is evidence that it can be done. But that, of course, leaves out the imponderable role of Tim Rollins who may, after all, be simply unique. The creative human personality may be irreplaceable, even if it is beyond doubt that Rollins's powers as an artist have been amplified and enhanced by being able to draw upon the collective creativities and imagination of K.O.S.

In the "Amerika" series, the works themselves are stunning, composed of golden horns and twined letters on the almost silver whiteness of the printed pages which support the surface like ghostly rectangles of gold leaf. Each of the letters has a local meaning—for example, HB for Howard Beach in *Amerika VI*—but it is the way horns and letters tangle and untangle that gives the works their beauty, as if they were so many illuminations for some Book of Kells. The Kids see the horns as fighting, but I do not. Possibly an interpretation along those lines could be given if we look for a moment at the wild variety and improbability of the horns. It is as though anything turns into a horn if given a mouthpiece and a bell, hence anything is potentially a horn, however antecedently unlikely (a metaphor for making artists out of those whom society perceives as misfits).

There is an extravagant imagination inventing these horns, whose fantasy and variety are reminiscent of the creatures of Bosch. Who knows but that we are looking at some evolutionary struggle, the question being which horn is best suited to survive? I once walked through a museum of musical instruments in Vienna and was astonished by the variety of discarded instrumental forms. It was as though the present instruments of the orchestra had undergone an evolutionary descent quite like that through which homo sapiens did, emerging as culminations. But this interpretation may be wildly off. I prefer the interpretation which suggests that there is music in everything if we but know how to play it, and hence there are possibilities of harmony once we are equipped to transform breath into art.

Sources

The incident from Hunt and Millais comes from Gay Daly, *Pre-Raphaelites in Love* (New York: Ticknor & Fields, 1989.) The curious view of Savonarola is discussed in Ronald Steinberg, *Fra Giroloma Savonarola, Florentine Art, and Renaissance Historiography* (Athens, Ohio: Ohio University Press, 1977.) The concept of "mastery-oriented personalities" has been explored by Carol S. Dweck. See "An Analysis of Learned Helplessness: Continuous Changes in Performance, Strategy, and Achievement Cognitions Following Failure," *Journal of Personality and Social Psychology* 36, no. 5 (May 1978). The distinction between Master and Genius is much elaborated in my essay "Masterpieces and the Museum," forthcoming in *Grand Street*.

ANNOTATED CHECKLIST
NOTES BY TIM ROLLINS

1

Notes on Amerika I—XII

AMERIKA I

1984-85, oil paintstick, acrylic, china marker, and pencil on book pages on rag paper mounted on canvas, 71½″ × 177″. Collection of the Chase Manhattan Bank, New York

Participating members of K.O.S.: Abimael Abad, Raul Alvavardo, Margarita Aruaya, Jose Carlos, Juanita Carlos, Radames Crespos, Rene Crespos, Abimael Cruz, Luis Feliciano, Aida Guach, Rolando Loboy, Felix Martinez, Ishmael Mendez, Joseph Nieves, Higinio Ocaslo, Otoniel Nieves, Carlos Rivera, Edwin Rivera, Michael Rivera, Roy Rogers, Annette Rosado, Jesus Ruiz, Jose Ruiz, Luis Santiago, Henry Tilo, Gregorio Torres, Oscar Torres, Maria Victoria, Frank Zayas

The idea of making a work based on Kafka's unfinished novel *Amerika* developed from a variety of influences at once. My first introduction to the book came indirectly, by way of an article I read in the September 1984 issue of *Artforum* during a lunch break at I.S. 52 that fall. The subject of the piece was *Class Relations*, a new work by two filmmakers I deeply admire, Jean-Marie Straub and Danièle Huillet. According to J. Hoberman's article, *Class Relations* was based on Kafka's *Amerika*, with emphasis on the novel's final chapter, "The Nature Theatre of Oklahoma." I don't know if it was the black and white photo illustrating the article—the one where young Karl is sitting upright in bed as if just suddenly awakened from a dream (1)—or simply the idea of a young teenager traveling across America in search of an identity and purpose—but I felt a strong, intuitive attraction to the sense of the story.

The same day immediately after teaching, I went downtown to the St. Mark's Bookshop and bought a Schocken paperback edition of the novel. Reading the last chapter first, I knew there was something in the text for us in the South Bronx.

Another consideration was the growing dissatisfaction within our group and community criticism that our previous works—e.g., the bricks, *1984*, *Dracula*, and *Frankenstein* (2)—were too indulgent in negative imagery. The kids and I had come to the point in our art where simply holding a mirror to the vital problems of the neighborhood wasn't enough. Expressionist paintings of burning buildings, people turning into monsters, lurid colors and violent compositions didn't tell the local community anything it didn't already know through everyday lived experience. Works like these, despite their good intentions, only served to reinforce and even reproduce the dominant culture's long-held, one-dimensional view of the South Bronx and its inhabitants.

In the time just before the first "Amerika" painting, there was the pressure, the desire, *the need* to create a work of art that was political, vital, critical, and yet *beautiful* all at once. The textile and wallpaper designs of William Morris and his workshop (3) from the late nineteenth century in England pointed to a way to reconsider the languages possible for a new political art—an art political not so much in its form or content, but political in the very way it is made. (I still find it amazing that the greatest indictment of capitalism can be found in but a yard of Morris's perfect, beautiful materials.)

In retrospect, I also remember that in late 1984 I was preoccupied with collecting notes for an essay (never completed as is too often the case) on the art of Dr. Seuss. I was interested in the pandemonium and libido of his language, narrative, and illustration and in the political allegory found in books like *The Cat in the Hat, If I Ran the Zoo,* and especially, *Horton Hears a Who!.* At the same time, I was enthusiastically winding my way through the writings of Gilles Deleuze and Felix Guattari. My favorite essay was "Rhizome" with its talk of rootlessness, "lines of flight," "movements of deterritorialization" and "being multiplicities." Such ideas were far more useful and liberating than the chic fatalism of poet-philosophers such as Jean Baudrillard. Also, looking back, I'm sure that the ideas of John Cage were lurking in my mind at the time of *Amerika I.*

Work on *Amerika I* began at 9:00 a.m. on January 6, 1985 in Room 318 of I.S. 52. The kids and I were fresh from Christmas vacation. I had six different classes that day (not including lunch duty) so I read aloud the beginning of "The Nature Theatre of Oklahoma" six different times with six different groups of students (about 100 kids in all) who drew on 8 × 10″, white, mimeograph paper pinched from another department in the school. As usual, I asked the kids not to illustrate what I was reading but to try to relate the story to things they were familiar with in their everyday lives.

Out of the piles of pencil drawings made during those first few days of reading, listening, and sketching, two motifs emerged over and over: angel wings and long horns. Both images directly related to the passage in the chapter where young immigrant Karl seeks to join the utopian artists' commune The Nature Theatre of Oklahoma and travels to a race-track in order to sign up. Upon his arrival, Karl encounters "a confused blaring; the trumpets were not in harmony but were blown regardless of each other." Upon further investigation, Karl discovers that this cacophony is being created by "hundreds of women dressed as angels in white robes with great wings on their shoulders were blowing on long trumpets that glittered like gold."

After weeks of work, it seemed like the kids couldn't get beyond copying the wings and instruments depicted in Emlen Etting's illustrations for the edition of *Amerika* we were using in class. Often breaking into originality comes from attacking a problem over and over again. But the more I repeated the assignment, the more the kids' boredom and resistance hardened. Even my most talented and dedicated students—Carlito Rivera and Annette Rosado, both twelve—were beginning to complain or give up.

One day, one of the most enthusiastic kids, Gregorio Torres, returned to school after being truant for over a week. Before I could chew him out, Greg handed me a large envelope stuffed with over thirty small drawings of horns—all of them different and strange. The other kids in the classroom were impressed. Soon, they all began to compete with each other, trying to "out-weird" each other in the design of their horns. It was one of those rare and wonderful "Eureka!" days.

The next day I gave an assignment asking the kids to represent their freedom and their unique voice in the form of a golden horn. With Gregorio and Co.'s studies as examples, over 100 kids went to work and the project exploded. Many of the students produced up to thirty studies leading up to one drawing that seemed "right" to themselves, to the other kids, and to me—horns that weren't too literal or corny; horns that seemed familiar and honest; and then again, forms never seen before. Some kids started to make several variations on their first successful studies. It was time to begin thinking about making a large painting.

There was no money for large stretchers and linen, so I found and purchased a huge remnant sheet, about 6 × 15′, of heavyweight Saunders rag paper. Using archival jade glue, I affixed the 298 pages of *Amerika* onto the sheet. Since the work had to be made with the sheet hanging, there was a problem. I called Leon Golub who told me how I could put grommets along the edges of the rag paper as he does in his big, unstretched canvases. It worked. (Recently, this painting was mounted on canvas for archival reasons.)

Finding the proper gold paint was also a difficult problem. We began preparing for *Amerika I* by making a small study on a ground of pages from only the chapter "The Nature Theatre of Oklahoma." (This study was later first exhibited in Group Material's *Americana* installation in the 1985 Biennial exhibition at the Whitney Museum of American Art.) The paint used for this crude study was a gold watercolor made by the German company Pelikan. After trying practically every gold paint available, this watercolor was unmatched in its ability to denote not only gold and wealth, but warmth, religiosity and soul. It seemed impossible, if only because of the expense, to use scores of little pans of this paint

2

3

4

5

for the large work. Finally, we decided to use "Markal" gold, oil-based paintsticks.

The ground of rag paper and book pages was hung across one of the two long walls in our cramped classroom, blocking the windows, but it was the only wall in the room with an uninterrupted, flat surface. Using the transparent cellophane cut from a bunch of old book covers discarded from the school library, the kids and I began tracing our original horn designs onto the clear sheets with fine-point, black-ink marking pens. Using the science department's overhead projector on a rolling utility cart, we traced the horn shapes onto the book page ground with light pencil, enlarging or reducing the size of each image by changing the position of the projector forwards or backwards.

In the beginning of making *Amerika I*, the composition was developed almost at random, practically by chance. One kid would put his design up, and then influenced by the previous placement and the general opinion of the other kids in the room, another kid would place his or her horn in relation to the other. Surprisingly, there were no serious arguments about one kid's horn being larger or more prominently placed than another's. It became clear that some horns looked better larger and some better smaller. Making the best painting possible all together became the priority.

As the painting progressed, we were reminded of other art works from history, like Mayan tapestries (4) and Pollock's *One* (5) that we had seen at the Museum of Modern Art. One kid thought the piece was beginning to look like the uptown Number 6 train during rush hour "when everybody is packed together." We wanted our golden instruments to look three-dimensional, but we also wanted them to form a very flat screen in front of the text—a tissue of images.

We continued to add horns until we all agreed the painting had reached a point of overload, and we used over forty in all. Then I worked with the kids most interested or adept in using the gold paintsticks for filling in and rendering the horn shapes and then adding some shading with black and gray paintsticks. We completed the painting in early May.

Amerika I was exhibited very shortly after being finished, in a group show, "Social Studies" curated by Richard Flood for the Barbara Gladstone Gallery. The painting was sold to the Chase Manhattan Bank Collection for $5,000. We took our share from this first major sale, $2,500, and used it as matching funds for a grant from the National Endowment for the Arts, securing the Art & Knowledge Workshop's present studio space in a community center on Longwood Avenue. K.O.S. and I could now make work independently from the public school system.

7

6

AMERIKA II

1985-86, oil paintstick, acrylic, china marker, and pencil on book pages on linen, 84" × 168". Saatchi Collection, London

Participating members of K.O.S.: Luis Feliciano, James Gillian, Aida Guach, Richard Lulo, Ishmael Mendez, Carlos Rivera, Annette Rosado, Luis Santiago, Henry Tilo

Amerika II was the first painting made after school and on weekends in our new studio which was located only two blocks from I.S. 52. We worked on this painting from May 1985 through late January 1986.

After much discussion, the kids, reduced to about fifteen of the most interested and talented, and I decided that *Amerika I* may have been "too much," with the singularity of the horns often lost in the jungle of the dense composition. We wanted *Amerika II* to be less manic, more delicate, with more attention given to the unique qualities of each individual horn. The instruments in *Amerika I* were stuffed into the space provided by the ground of book pages, with little free space to be seen. In contrast, we planned *Amerika II* to be a breathing, lilting, and even lovely painting. This time the horns would *float* on the surface of the text.

Carlos Rivera, Edwin Rivera, and I began raiding our makeshift art library for ideas for the horn motifs. Edwin started taking forms from the notebooks of Leonardo (6), doing hilarious things with the anatomy drawings. Carlos copied a pair of antlers from a reproduction of Georgia O'Keeffe's painting *Summer*

Days, 1936, and mounted them on top of his usual cruciform horn designs.

We also traced the contours of some "Chinese stars" (7)—small, dangerous, steel, throwing weapons with sharp points and edges that I was constantly taking off of kids who were carrying them to school under the influence of the "Ninja" movie craze going on then. I would always be upset when kids showed them to me, but then again they were cool and I could understand why the kids liked them. They did emit a sense of power and magic. After drawing from them, however, they were completely banned from the classroom and studio. *Amerika II* also contains forms borrowed from graffiti, maps of the U.S., and designs for horns made in preparation for *Amerika I* which were completely invented.

We still couldn't afford a large custom stretcher, but we did order two prefabricated units that could be put together. We learned how to stretch Belgian linen which we would gesso before affixing all the pages of the *Amerika* book, again with jade glue.

Amerika II was first exhibited in a show shared with Nan Goldin at Jay Gorney Modern Art at 204 East 10th Street in New York in February 1986. It was the second large work of ours sold, purchased for the Saatchi Collection in London. I received news of the sale while I was working during a depressing parent-teacher night at I.S. 52—a very strange evening for me.

AMERIKA III

1985-86, oil paintstick, china marker, and pencil on book pages on linen, 74″ × 164¾″. The Oliver-Hoffmann Collection, Chicago

Participating members of K.O.S.: Luis Feliciano, Aida Guach, Richard Lulo, Robert Mollica, Carlos Rivera, Edwin Rivera, Roy Rogers. Annette Rosado, Luis Santiago

In reaction to the relative calm of *Amerika II*, the kids and I wanted to make the next painting in the series "look like a rumble"—a real demolition derby. Again, it was a two-panel work prepared like *Amerika II*. We considered a picture that would be a synthesis of the issues explored in both *Amerika I* and *II*. This time we paid far more attention to making a complex, formal composition. Studying reproductions of Uccello's *Battle of San Romano* panels (8) was important to this process. We also spent a lot of time looking at Philip Guston's 1970 lithograph *The Street*, (9) its painted version at the Metropolitan Museum, the crying women from Picasso's *Guernica* (10), and again tribal tapestries. For designs of individual horns we looked at classic war masks, ceremonial objects, (11) and knives from Western Africa (12), ads for jewelry in the backs of heavy metal rock fan magazines, Scott-

8

9

10

11

12

13

14

16

Giles's diagrams of the rings of Dante's *Inferno*, death sickles from old Daumier cartoons (13), and other references.

Amerika III was made from December 1985 to late April 1986. It was first exhibited in a group show at the Lawrence Oliver Gallery, Philadelphia, and was acquired by the Oliver-Hoffmann Collection in Chicago.

AMERIKA IV

1986, lacquer with metallic powder, oil paintstick, and pencil on book pages on linen, 72″ × 180″. Collection of Virginia Wright and Clay Rolader, Atlanta

Participating members of K.O.S.: James Gillian, Richard Lulo, Robert Mollica, Carlos Rivera, Edwin Rivera, Roy Rogers, Annette Rosado, Luis Santiago, Henry Tilo

The kids and I have always thought of *Amerika IV* as our first "science fiction" painting. A major inspiration was the films of director David Cronenberg, in particular his movie *Scanners* (14). A common theme throughout all of Cronenberg's horror films is the collapse of psychology and biology, with one force mutating the other. (The kids and I occasionally go to movies together for entertainment, only to find elements from these films sneaking into our collaborative work.)

While planning *Amerika IV*, the kids and I began to discuss the place of these paintings in the tradition of *brujería* (black magic) and *santería* (white magic)—magic-religious forms and practices familiar to most of the kids, especially those with roots in the Caribbean. Instead of literally borrowing forms from this magic—candles, statues, animal parts, insects, concoctions—we began to see how the paintings functioned for us and our audiences as both charms and curses simultaneously. As long as we are intensely engaged in making this art, we are "protected" from the evil forces present in the streets. Yet, the works also pose an opposition against those individual or social forces that would wish us and our project failure or harm. Unlike Euro-Christian ideas of Heaven and Hell or Good and Evil as polar opposites in battle, the magic tradition of the Caribbean finds benevolent forces not only on the same life field as evil ones, but constantly reminds us of their interdependence. These are ideas we began to try to manifest in this "Amerika" painting and the ones to follow.

A formal discovery we made while working on this painting was the use of thin, tendril-like horns that activated the entire expanse of the painting space without clogging it up, and unified the instruments as they were growing in distinction and perversity. In this fourth "Amerika," the drawings begin to resemble the inside of some sort of body undergoing sinister transformations. Related

17

to this idea, we based a drawing on the figure of Annihilus from the Marvel Universe. (15)

This was the only work made with a combination of banana lacquer and gold metallic powder. Despite extensive precautions, the materials proved to be too toxic to consider using again.

Amerika IV was started in March 1986 and completed in time for inclusion in a group show curated by Josh Baer in May 1986 at the Rhona Hoffman Gallery in Chicago. *Amerika IV* was acquired by Clay Rolader and Virginia Wright from Atlanta for a public space in their city.

AMERIKA V

1985-86, watercolor, charcoal, acrylic, and pencil on book pages on linen, 66″ × 186″. Collection of Andrew Ong, New York

Participating members of K.O.S.: Jose Burgos, Richard Cruz, Johnny De Leon, Luis Feliciano, George Garces, Jose Parissi, Carlos Rivera, Annette Rosado, Nelson Savinon, Yesenia Velez

Amerika V was conceived as a landscape or, to be more specific, a *battlefield*. We returned to our study of Uccello's battle paintings, combining these ideas with themes initiated in *Amerika IV*. In *Amerika V*, the instruments become weapon-like, with only a huge, solid "M" letter-form not in motion. I don't remember where the "M" came from except that when it was placed in the composition, the kids would ask each other: "Quick! What's the first word you think of that begins with the letter 'm'?" Ranging from "mother" to "money" to "murder," the responses were not only key words in the kids's lives but in the life of our society as well.

Again remnants from the world culture fly through *Amerika V*: African instruments and headdresses (16), images from Marvel

Comics, a logo designed by Rodchenko in 1923 (17), flying bricks and baseball bats, the outlines of ancient weapons from a book called *The Art of War*. Also again, the horn forms have become cancerous, doubling and tripling, suggesting a process growing dangerously out of control.

Amerika V was painted from designs and plans started in late 1985. It was completed in August of 1986 and first exhibited in a group show at the Brooke Alexander Gallery in New York. *Amerika V* was acquired for the collection of Andrew Ong, New York.

AMERIKA VI

1986-87, watercolor, charcoal, acrylic, and pencil on book pages on linen, 66″ × 139″. Saatchi Collection, London

Participating members of K.O.S.: Jose Burgos, Richard Cruz, George Garces, Nelson Montes, Emily Pagan, Jose Parissi, Carlos Rivera, Annette Rosado

The sixth "Amerika" painting was made under an extreme deadline specifically for the exhibition "Out of the Studio," curated by Tom Finkelpearl and Glen Weiss for P.S. 1 (Public Studios One) located in the Long Island City section of Queens. "Out of the Studio" included artists who make their work in a community context.

Amerika VI was made in direct response to the Howard Beach incident in Queens in which three black men were attacked by a group of white teenagers, ultimately resulting in the death of one of the victims who was struck and killed by an automobile while trying to escape. The painting retains the riotous composition of the third, fourth, and fifth works in the series, but this time the picture plane is flanked and bracketed by two huge letters, "H" on the left and "B" on the right. While the letters obviously stand as initials for Howard Beach, they also signify the name Hieronymous Bosch and the netherworld this artist represents.

Many original, invented horn designs permeate this work, yet all still refer to the panic and violence of the Howard Beach tragedy. Nelson Savinon's perpetually repeating checks run through the middle of the painting. Annette Rosado's bones with wings and George Garces's crutch forms also appear. They share the space with spider-like robots (perhaps inspired by the movie version of H.G. Wells's *War of the Worlds*), baseball bats, and body organs-turned-weapons.

Amerika VI was designed from September 1986 to late January 1987. The entire work was painted in five days, from January 18th to January 22nd. "Out of the Studio" opened at P.S. 1 on January 25, 1987. After the exhibition, *Amerika VI* was the second "Amerika" painting to be acquired by the Saatchi Collection.

AMERIKA VII

1986-87, watercolor, charcoal, acrylic, and pencil on book pages on linen, 64″ × 169½″. Collection of the Philadelphia Museum of Art. Purchased with funds contributed by Marion Stroud Swingle, Mr. and Mrs. David Pincus, Mr. and Mrs. Harvey Gushner, and Mr. and Mrs. Leonard Korman

Participating members of K.O.S.: Angel Abreu, Richard Cruz, George Garces, Nelson Montes, William Lugo, Jose Parissi, Carlos Rivera, Annette Rosado, Nelson Savinon

Amerika VII was another painting made for a specific context and event—an exhibition at the Lawrence Oliver Gallery in Philadelphia on the occasion of the Bicentennial of the Constitution of the United States.

I read Jefferson's Declaration of Independence with K.O.S. For each of the students this was their first encounter with the document. The kids considered the parallels and contradictions between the pursuit of happiness as envisioned by Jefferson and the

18

19

20

21

22

Founding Fathers in 1777, the dreams and disappointments of Kafka's protagonist Karl, and the reality of living in the South Bronx in 1987.

The horns were derived from the broadest panorama of sources yet. We traced the "M" chalked on the back of the child-murderer played by Peter Lorre from a T.V. screen while playing a videotape of the famous Fritz Lang film. We used the crown of thorns worn by Grünewald's crucified Christ figure from the *Isenheim Altarpiece*; Carlito Rivera chose one detail of the crown, repeating that to form a new crown (18). The planet-like shape of the AIDS virus was copied from the Science Section of a Tuesday *New York Times* (19). We borrowed the super-sensitive ear of the elephant Horton from Dr. Seuss's classic *Horton Hears A Who!*. (20) We developed a horn from the outline of an automatic attack rifle—the weapon of choice for mercenaries and local drug dealers alike—from the ad pages in the back of a popular gun magazine (21). Richard Cruz paid homage to one of his favorite artists, Louise Bourgeois, by imitating the shape of one of her sculptures. George Garces took the figure of a standard bishop chess piece and presented it as a flaccid penis. We also were looking at plates from a classsic "anatomy for artists" manual. (22) Along the top and bottom of the painting run the years 1777 and 1987 represented in Roman numerals rendered in "Times Roman" style. Between the two rows of numerals grow straight extensions that are reminiscent of prison bars.

Amerika VII was planned and painted from September 1986 to April 1987. The painting was acquired for the permanent collection of the Philadelphia Museum of Art.

AMERIKA VIII

1986-87, watercolor, charcoal, acrylic, and pencil on book pages on linen, 68″ × 168″. Collection of The Museum of Modern Art, New York. Jerry I. Speyer Fund and Robert and Meryl Meltzer Fund, 1988.

Participating members of K.O.S.: Angel Abreu, Jose Burges, Robert Delgado, George Garces, Richard Lulo, Nelson Montes, Jose Parissi, Carlos Rivera, Annette Rosado

After *Amerika VII* we were faced with the same dilemma presented after the first "Amerika" painting—too much information, too much quotation, too much violence.

"For two days and two nights they journeyed on. Only now did Karl understand how huge America was." This passage from the final lines of Kafka's novel guided the feeling we wanted for our *Amerika VIII*. We wanted to make a landscape of hope and pos-

sibility—a space of expansion, growth and endless potential. For this painting all of the designs for horns were imagined and invented. Featuring only twenty-two horns, *Amerika VIII* provided an opportunity to contain all the lessons, forms, and contents of all the previous "Amerika" paintings in one panoramic work.

One of the K.O.S. members involved in the making of *Amerika VIII*, Richard Lulo was later tragically shot and murdered by unknown assailants for a gold chain the young artist was wearing. This painting is dedicated to his memory.

Amerika VIII was made from September 1986 to September 1987. It was first exhibited at the Rhona Hoffman Gallery in Chicago and was acquired for the permanent collection of The Museum of Modern Art, New York.

AMERIKA IX

1987, watercolor, charcoal, acrylic, and pencil on book pages on linen, 64″ × 168″. Collection of the Mint Museum of Art, Charlotte, North Carolina. Gift of the artists and Knight Gallery, Spirit Square Arts Center, with support of the North Carolina Arts Council

Participating members of K.O.S.: Angel Abreu, Howard Britton, Jose Burges, Richard Cruz, Robert Delgado, George Garces, Angel Hernandez, William Lugo, Richard Lulo, Jorge Luis Muñiz, Nelson Montes, Jose Parissi, Carlos Rivera, Annette Rosado, Nelson Savinon, Yesenia Velez

Students from Charlotte, North Carolina: Rosannia Adams, Jameriam Black, Jermaine Black, Tammi Filling, Eric Frazier, Eveco Danillia Haggins, Ralph Jannelli, Chris Lyon, Benjamin Mayfield, Amy Nance, John Peed, Renee Sanders, Brooke Tolman, Shawn Bauknight, Angie Bell, Elisha Brownd, Roscoe Fox, Trevor Frick, Carol Herin, Otis Lockhart, Kim Martinez, Linda Mungo, Neil Nivens, John Rillo, Emily Marie Scripter, Christy Vagianos

Amerika IX was the first of the three "Amerika" paintings made in collaboration with youths from communities outside of the South Bronx. It was made during an exhibition organized by Ann Shengold for the Knight Gallery in Charlotte, North Carolina. "Everyone is Welcome!" was the title of the exhibition, surveying five years of work from 1982 through 1987, including works from our "Alice in Wonderland," "Fahrenheit 451," "Animal Farm," "The Whiteness of the Whale," and "The Red Badge of Courage" projects, among others. The stretched but unpainted ground of book pages from *Amerika* was also exhibited. The exhibition had two openings, the first on November 13, 1987. During the following five days, five K.O.S. members and I worked with about nine young people recruited from schools and a nearby housing project

in the Charlotte community to render the painting. The gallery space was transformed into an open studio where visitors could watch the collaborative process and the making of *Amerika IX* take place. The students and I were available for dialogue and answering questions during these intense, concentrated work sessions. The making of *Amerika IX* was widely reported in the local media. The second opening took place on November 18th with the completed *Amerika IX* included in the exhibition.

The exchange between the kids from the South Bronx and the local Charlotte youth was interesting and enthusiastic. While the Bronx kids came to North Carolina expecting rednecks in pick-up trucks, some of the Charlotte kids eventually confessed worrying about these wild, hip-hop graffiti fiends coming down from the big city in the North. Stereotypes dissolved immediately through the making of the art.

The symbolism of the horns was significantly different in *Amerika IX* from earlier works in the series. *Amerika IX* contains more organic, rural, plant-like forms than any work made in the Bronx. Staff-like horns evoking memories of ancient Africa and Egypt are dominant along with bird-like forms in flight. Like *Amerika I* and *VIII*, all the horns were original, without reference to historical models or outside sources.

We wanted the painting to stay in the community in a public collection. Through the efforts of many people, it was acquired for the Mint Museum of Art in Charlotte.

AMERIKA X

1986-88, watercolor, charcoal, bistre, acrylic, and pencil on book pages on linen, 60″ × 175″. Collection of Robert and Susan Sosnick, Detroit

Participating members of K.O.S.: Angel Abreu, Howard Britton, Brenda Carlo, Jose Carlos, Richard Cruz, Robert Delgado, George Garces, Nelson Montes, Jose Parissi, Carlos Rivera, Annette Rosado, Stephen Rust, Nelson Savinon

The tenth "Amerika" painting was the longest in planning, from April 1986 to the end of February 1988, and it was planned at the time to be the last of the "Amerika" paintings. Just as work on *Amerika X* was nearing completion, K.O.S. and I decided to make another "Amerika" painting as part of a large exhibition of our work curated by Lawrence Rinder for the Walker Art Center in Minneapolis. Work stopped on *Amerika X*, and *Amerika XI* made with kids from Minneapolis was actually finished first.

The theme of *Amerika X* is one of doubling and negation, of a struggle between the organic and the geometric, the physical and

the abstract, the irrational and the logical. But in it, we returned to several themes explored not only in previous "Amerika" and "Nature Theatre of Oklahoma" works, but in work from other series, especially "The Autobiography of Malcolm X." (23) We began to see the "X" in other sources (24) reinforcing our sense of its multiple meanings. The number "10" became the Roman numeral "X" which, in turn, became a cipher for cancellation and, as in many of the past paintings, a biological process of uncontrollable doubling.

We also reorganized the placement of the book pages to allow for a more horizontal format, suggesting a rushing flow of histories, a moving body of water as described by Heraclitus in his proverb, "You can't stick your foot in the same river twice."

The last element added to *Amerika X* was the central horn resembling simultaneously a double fetus and the mushroom shape of an atomic bomb blast. This design came out of collaboration between me and a student from Minneapolis, Stephen Rust, 15, while working on the Walker Art Center project. This particular design seemed *made* for *Amerika X*, and Stephen was extremely dedicated to the project and to us as teachers and friends. So we flew Stephen from Minneapolis to the South Bronx to help us complete *Amerika X*.

Amerika X was first exhibited at Jay Gorney Modern Art in March of 1988. It was acquired for the collection of Robert and Susan Sosnick in Detroit.

24

23

AMERIKA XI

1988, watercolor, charcoal, bistre, acrylic, and pencil on book pages on linen, 68″ × 158″. Collection of First Bank System, Inc., Minneapolis

Participating members of K.O.S.: Angel Abreu, Howard Britton, Jose Burgos, Jose Carlos, Richard Cruz, Robert Delgado, George

25

26

Garces, Angel Hernandez, William Lugo, Jose Mojica, Jorge Luis Muniz, Nelson Montes, Pablo Ortiz, Emily Pagan, Jose Parissi, Carlos Rivera, Annette Rosado, Nelson Savinon, Yesenia Velez

Students from Franklin Junior High School, Minneapolis: Sean Brewington, Jackie Brown, Shilo Buchanan, Tina Dean, Greg Donovan, Christina Garcia, Vincent Gilbert, Linda Gohlke, Don Hackett, Mateshia Hawkins, Sunrise Hill, Jodi Katchmark, Stephen Rust, Tom Spiess, Tanya Tabor, Nathan Thompson

Amerika XI was made in collaboration with sixteen teenagers from Franklin Junior High School in Minneapolis. Working in conjunction with five members of K.O.S., the Minneapolis students, accompanied by their art teachers, came to the education department of the Walker Art Center which had been transformed into an ad hoc studio for the rendering of the painting.

As in the Charlotte painting, all the forms for *Amerika XI* were original designs but with regular, symmetrical figures predominating. When it was time to compose the individual horns into one unified work, the consensus reached by the entire group was to place the instruments in a "peaceful and floating" manner, a projection of a desired harmony.

The February 17 opening of the exhibition featuring *Amerika XI* produced a huge, non-art world community turnout at the Walker Art Center. The painting was purchased by First Bank System of Minneapolis for its collection.

AMERIKA: FOR THOREAU

1987-88, watercolor, charcoal, bistre, acrylic and pencil on book pages on linen, 60¼" × 175½". Collection of Vijak Mahdavi and Bernardo Nadal-Ginard, Boston

Participating members of K.O.S.: Angel Abreu, Howard Britton, Richard Cruz, George Garces, Nelson Montes, Pablo Ortiz, Jose Parissi

Students from English High School, Boston: Robert W. Blair, Keith Cappuccio, Hans Desrosiers, Jennifer Goss, Norma Hickey, Michael Macchi, Brett Michel, Frank Tipping, III

This painting was made in conjunction with an exhibition of our work as part of the "Currents" series at the Institute of Contemporary Art in Boston. Seven members of K.O.S. and I, in cooperation with the Director of Education at the ICA, Chris Holderness, planned to make an "Amerika" work in homage to the thought of Henry David Thoreau. We collaborated with eight high school students from an alternative program at English High School in Boston.

Amerika: For Thoreau was made in the small, street-level gal-

lery at the ICA, Boston, over seven days in late March 1988. As in the Knight Gallery project, during this "open studio," journalists, teachers, artists, friends, and other visitors could observe the art-making process and discuss the work with us.

Despite my New England upbringing, I only started seriously studying the philosophy of Emerson and Thoreau in early 1988. Emerson's essay on "Self-Reliance" and the chapters on "Economy" and "Reading" from Thoreau's *Walden* made an enormous impact. The issues discussed in these writings seemed absolutely contemporary and radical to me, and they still do today. I liked Thoreau's "pedagogy" as demonstrated in the fourteen volumes of his *Journals*. His is a learning based on concentrated observations of material reality during the act of *wandering*—allowing the free association of thoughts to provide the curriculum for the day. The process of education becomes a personal, epic odyssey through the totality of world culture.

While I encouraged the Boston kids to develop their own horn designs for the work, I also presented them with photocopies of the sketches Thoreau made in his *Journals*—often strange, tiny drawings of leaf forms, patterns of cracks in an iced-over country pond, and other natural forms. Also, John Cage made a series of prints based on these little drawings taken from the Dover edition of the *Journals*, (25) and these influenced the kids's drawings as well. These examples inspired variations created by both the K.O.S. members and the Boston students working on the project. For example, the central wheel-like form at the center of the painting was derived from a drawing by Thoreau of the underside of a mushroom cap. (26)

Amerika: For Thoreau was acquired by Boston collectors Vijak Mahdavi and Bernardo Nadal-Ginard through the Barbara Krakow Gallery, Boston, in cooperation with Jay Gorney Modern Art, New York.

AMERIKA XII

1988-89, watercolor and pencil on book pages on linen, 60" × 180". Collection of the Art & Knowledge Workshop, South Bronx, New York

Participating members of K.O.S.: Aracelis Batista, Brenda Carlo, Richard Cruz, George Garces, Christopher Hernandez, Nelson Montes, Jose Parissi, Carlos Rivera, Annette Rosado, Nelson Savinon

Amerika XII is a meditation on the *idea* of midnight—the point at which a day dies and a day begins. Works such as Odilon Redon's 1883 charcoal drawing, *The Masque of the Red Death*—shown to

us by Bernice Rose at The Museum of Modern Art's Department of Drawings Study Center (27)—a sketch of a dying tree by George Grosz from a 1917 sketchbook, (28), a reversed Roman numeral XII from an early drawing of a clock by Paul Klee (29), and an etching by James Ensor (30) influenced drawings made for this painting. General death symbols from medieval European, African, Mayan, and Caribbean cultures all exert important influence on the imagery and timbre of this work.

We began developing the ideas for *Amerika XII* in April 1988, but we did not begin making the painting until late June 1989. At that time we set up a temporary, summer studio on West 19th Street in Manhattan, offering some relief from the constant tension and danger due to the sharp rise in drug and gang activity that has been gradually taking over Longwood Avenue in the Bronx. The painting was completed on August 9, 1989.

Amerika XII will be the first of our large-scale works to remain in the permanent collection of the Art & Knowledge Workshop.

Notes on Related Works

1. MURAL

Amerika—For the People of Bathgate, 1988, Community Elementary School 4, 1701 Fulton Avenue, Bronx, mural on Bathgate Avenue between 173rd and 174th Streets, enamel paint on exterior wall, 55 × 36'. Conceived in six two-hour sessions from April 18-29, 1988. Completed October 6, 1988. Executed by Jerry Johnson, Orange Outdoor Advertising. Sponsored by the Public Art Fund, Inc., New York with support from The Port Authority of New York and New Jersey, Bronx Borough President's Office, and Art & Knowledge Workshop, Inc., South Bronx

Participating members of K.O.S.: Angel Abreu, Howard Britton, Brenda Carlo, Richard Cruz, George Garces, Nelson Montes, Pablo Ortiz, Carlos Rivera, Annette Rosado, Nelson Savinon

Students from Community Elementary School 4: Anna Boutelle, Jose Colon, Eliana Fernandez, Armando Figueroa, Luis Figueroa, Bruce Franco, Isalene Goldman, Stan Kaminsky, Steven Marcias, Melissa Marquez, Luis Medina, Eddie Milian, Roberto Ortiz, Eddy Ramirez, Kareen Simmonds, Shamel Simmons, Saladin Smith, Daniel Torres, Kenneth Washington

2. STUDY DRAWINGS

Since 1985, more than 500 watercolors have been made on single pages, 7 × 5", from the paperback edition of *Amerika*. These watercolors are usually the first serious and completed work made by new members of K.O.S. The making of these small works on

27

28

29

30

31

32

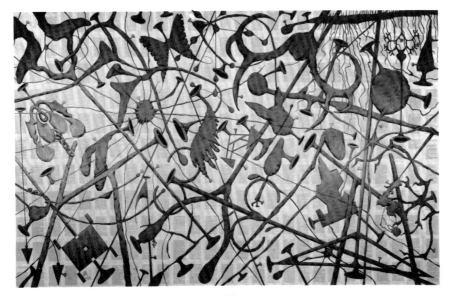

33

paper provides the crucial "training ground" on which the drawing, painting, rendering, and design skills of the young artist are first tested. Kids must prove they can successfully create the study before they are allowed to begin work directly on the larger paintings. The older, more experienced kids continue to make study drawings as they develop horns for new paintings.

Also, the deliberate making and offering of original works of art for $500 or under was directly inspired by the example of Joseph Beuys and his radical innovation of the "multiple." We consider that not only the form, the content, and the method but also *the distribution* of the work are an integral part of the artwork as "an ensemble of social relations."

Sometimes study drawings are made as a cohesive group. The first such work, *A Country House Near New York*, 1987-88, includes forty-four pages, each framed separately. Subsequent groupings include *Uncle Joseph* and *A Refuge*.

3. "THE NATURE THEATRE OF OKLAHOMA"

A number of small paintings have been made generally using only pages from "The Nature Theatre of Oklahoma," the last chapter of *Amerika*.(31) These works often are done in square or almost square formats as small as 6×6″, but usually larger, 15×16″ or 32×32″, using only a few drawings in the composition. Some paintings have been made as horizontal compositions, about 24×42″, using many drawings. The first "Nature Theatre of Oklahoma" was done as a formal study, completed in March 1985, in preparation for work on *Amerika I*. Otherwise, these are independent, small-scale works.

4. SMALL AND INTERMEDIATE-SCALE PAINTINGS

On occasion, in working on one of the large-scale "Amerika" paintings, we also have made smaller paintings, measuring about 24 × 42-48″. These paintings do not function as studies in the academic sense of testing compositions but allow variations on the "Amerika" themes on a more intimate scale with distinctions impossible to realize in the large-scale works. One small painting titled *Amerika South Bronx* was made along with *Amerika II*, one each with *Amerika VII* (32) and *Amerika X*, and four with *Amerika XII*. After the completion of *Amerika XII*, ten intermediate-scale works, each 60×48″, will be made as variations using many study drawings not included in the large-scale painting. One intermediate-scale work, 60×30″, was painted in preparing for the mural *Amerika—For the People of Bathgate*.

5. OTHER WORKS

Since 1987, we have been working with a new, large format further developing formal themes established in the numbered "Amerika" paintings. *Amerikas I-XII* belong to the tradition of landscape and history painting—from Uccello's *Battle of San Romano* to Courbet's *Burial at Ornans* to Picasso's *Guernica*—as they are all *statements*, with content found not only in the individual properties of each horn element but also, and more importantly, in the *relations* between these elements on the ground of the Kafka text. The new paintings, as in our "Red Badge of Courage" works, are more like universes or cosmologies—windows onto a fourth dimension of possibilities, each of these symbolized in the form of a golden horn. The new works allow the horn elements to float as if suspended in an embryonic fluid, waiting to be born and to become active material on the world. The compositions are freer with a more even, overall structure, and the forms are cut by the edges of the paintings, again reinforcing the idea of looking through an open window.

The Bathgate mural begins to develop these ideas, and two large paintings have been completed: *Amerika ∞*, 1987-88, watercolor, charcoal, and pencil on book pages on linen, 84×134″. Collection of Thomas Ammann, Zurich. This painting was exhibited in a group exhibition at Jay Gorney Modern Art, New York (33); *Amerika: For Karl*, 1988-89, watercolor, charcoal, and pencil on book pages on linen, 92″×132″. This painting was included in our solo exhibition in June 1989 at Galerie Johnen & Schöttle, Cologne, courtesy of Jay Gorney Modern Art, New York.

Reference Photographs

1. Jean-Marie Straub and Danièle Huillet, *Class Relations*, 1984. Still from black and white film in 35 mm, 126 minutes. Christian Heinisch as Karl Rossmann.

2. Tim Rollins + K.O.S., *Frankenstein*, 1981-84, acrylic on book pages on linen, 108″×144″.

3. William Morris, wallpaper design. From Norah C. Gillow, *William Morris Designs and Patterns* (London: William Morris Gallery and Bracken Books, 1988).

4. Mayan tapestry design. From Walter F. Marrs, *Living Maya* (New York: Harry N. Abrams, Inc., 1987)

5. Jackson Pollock, *One (Number 31, 1950)*, 1950, oil and enamel paint on canvas, 106″×209⅝″. Collection of The Museum of Modern Art, New York. Sidney and Harriet Janis Collection Fund (by exchange).

6. Leonardo da Vinci, *Muscles of the Lower Extremity #2*, Plate 119. From Fritz Schider, *An Atlas of Anatomy for Artists*, sixth (1929) edition, revised by Professor Dr. M. Auerbach, trans. by Dr. Bernard Wolf (New York: Dover Publications, Inc., third edition, 1957).

7. "Chinese stars", steel, approximately 2″–3″ each

8. Paolo Uccello, *The Battle of San Romano*, c. late 1440's, wood panel, 71⅝″×125¾″. Reproduced by courtesy of the Trustees, The National Gallery, London.

9. Philip Guston, *The Street*, 1970, lithograph, ed. of 120, 22¼″×30″. Published by Sherwood Press. Collection of the Art & Knowledge Workshop.

10. Pablo Picasso, *Guernica*, 1937 (detail). Copyright 1989 ARS N.Y./Spadem.

11. *Horned Head (Boli)*, Mali, Bamana, San district, Dyabougou village, gourd, clay, organic matter, diameter 5⅞″. Collection of The Musée de l'Homme, Paris.

12. *Fang Throwing-Knife Representing Bird's Head*, iron, 12″ Collection of British Museum, London. Courtesy of the Trustees of the British Museum.

13. Honoré Daumier, *"When Again?"*, etching. From *Daumier on War* (New York: Da Capo Paperback, 1977).

14. David Cronenberg, *Scanners*, 1981. Still from video of color film.

15. "Annihilus" from *Marvel Universe*. TM & Copyright 1989 Marvel Entertainment Group, Inc. All rights reserved.

16. *Janus Headdress*, Nigeria, Boki, Africa. Wood, leather, horns, paint, basketry, height 21¼″. Collection of Carlo Monzino.

17. Alexander Rodchenko, *Sketch for Dobrolet Trademark*, 1923, India ink and gouache on paper. From *Rodchenko, The Complete Work* (Cambridge: The MIT Press, 1987.)

18. Mattias Grünewald, *Isenheim Altarpiece*, completed 1515 (detail).

19. Diagram of an AIDS virus, *The New York Times*, Science Times Section, March 3, 1987, p. C1.

20. "Horton with the thistle of Whoville," Copyright 1954 by Theodor S. Geisel and Audrey S. Geisel. Reprinted from *Horton Hears A Who!* with permission of Random House, Inc.

21. Automatic assault rifle, advertisement for Ram-Line Firepower Trademark, Inc., Strum Ruger & Co., Golden, Colorado, 1989.

22. *The Bones of the Trunk, Anterior View* Plate 8. From Fritz Schider, *An Atlas of Anatomy for Artists*, sixth (1929) edition, revised by Professor Dr. M. Auerback, trans. by Dr. Bernard Wolf (New York: Dover Publications, Inc., third edition, 1957).

23. Tim Rollins, Franklin Darnell Smith + K.O.S., *By Any Means Necessary*, 1985–86, black gesso on book pages on linen, 68½″ × 148″. Photograph by Ken Schles.

24. Parlinah Mashiana, wall painting, Vaalkrans Farm, van Duksdrif district, South Africa. From Margaret Courtney-Clarke, *Ndebele: The Art of an African Tribe*, (New York: Rizzoli, 1986).

25. John Cage, *17 Drawings by Thoreau*, #16, 1978, color photo-etching, ed. of 25, 24″ × 36″. Published by Crown Point Press, San Francisco.

26. *Journals of Henry David Thoreau*, in 14 volumes, drawing from the sketchbooks (New York: Dover Publications, Inc., 1962, republished from the 1906 edition by Houghton Mifflin, Co.)

27. Odilon Redon, *The Masque of the Red Death*, 1883, charcoal on brown paper, 17¼″ × 14⅛″. Collection of The Museum of Modern Art, New York, John S. Newberry Collection.

28. George Groz, drawing from *Skizzenbuch 1917* (Siegen: Verlag Affholderbach & Strohmann, 1987).

29. Paul Klee, *Uhr mit romischen Zahlen* (Clock with Roman Numerals), 1916, pencil and colored crayon on paper mounted on cardboard, 4⅞″ × 7″, Kunstmuseum Bern, Paul Klee Stiftung. Copyright 1989 ARS N.Y./COSMO-PRESS.

30. James Ensor, *Death Dominating the Deadly Sins*, 1904, etching, 5½″ × 3½″. Collection of the Art & Knowledge Workshop.

31. Tim Rollins + K.O.S., *The Nature Theatre of Oklahoma III*, 1985–86, oil paintstick and china marker on book pages mounted on linen, 32″ × 32″. Photo by Ken Schles.

32. Tim Rollins + K.O.S., *Study for Amerika VII*, 1987, watercolor, and pencil on book pages on linen, 24″ × 42″.

33. Tim Rollins + K.O.S., *Amerika: ∞*, 1987–88, watercolor, charcoal, and pencil on book pages on linen, 84″ × 134″.

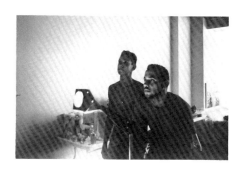 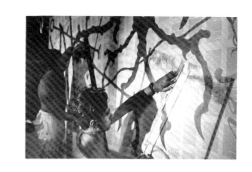 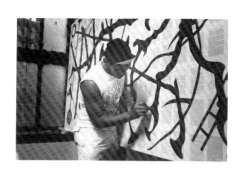

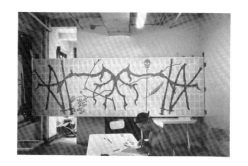 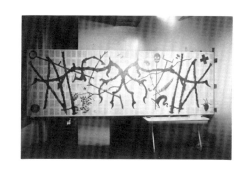 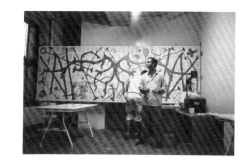

Tim Rollins + K.O.S.,
working in the studio on Amerika XII
Photographs by Tim Rollins + K.O.S.

81

BIOGRAPHIES

Tim Rollins

Born, 1955,
Pittsfield, Maine

1976–78
B.F.A. Department of Fine Arts,
School of Visual Arts, New York

1978–80
Department of Art Education,
New York University, New York

1979
Co-Founded Group Material, New York

1980–82
Artist/Teacher, "Learning to Read Through the
Arts Program," a special project of the Board of
Education of the City of New York; South
Bronx; Jamaica, Queens; Bushwick, Brooklyn;
Lower East Side, Manhattan

1982–87
Artist/Teacher, I.S. 52, South Bronx,
New York

1982
Founded K.O.S. (Kids of Survival) and the Art
& Knowledge Workshop, Inc., South Bronx,
New York

Students Currently Participating in K.O.S.:

Aracelis Batista
Born, 1974, New York
The High School of Art & Design, Manhattan

Brenda Carlo
Born, 1974, New York
The High School of Art & Design, Manhattan

***Richard Cruz**
Born, 1970, New York
LaGuardia High School, Manhattan

***George Garces**
Born, 1972, New York
LaGuardia High School, Manhattan

Christopher Hernandez
Born, 1978, New York
P.S. 130, Bronx

***Nelson Montes**
Born, 1972, New York
Smith High School, Bronx

***Jose Parissi**
Born, 1968, Ponce, Puerto Rico
LaGuardia Community College, Queens

***Carlos Rivera**
Born, 1971, New York
The High School of Art & Design, Manhattan

***Annette Rosado**
Born, 1972, New York
The High School of Art & Design, Manhattan

***Nelson Savinon**
Born, 1972, New York
John F. Kennedy High School, Manhattan

**long-term member of K.O.S.*

EXHIBITIONS

Tim Rollins + K.O.S.
Solo Exhibitions

1985 Bronx Museum of the Arts and Hostos Community
College, New York

1986 Jay Gorney Modern Art (with Nan Goldin), New York
Fashion Moda, South Bronx, New York
State University of New York, Old Westbury
Jay Gorney Modern Art, New York

1987 Lawrence Oliver Gallery, Philadelphia
Rhona Hoffman Gallery, Chicago
Knight Gallery, Charlotte, North Carolina

1988 Jay Gorney Modern Art, New York
Walker Art Center, Minneapolis
Institute of Contemporary Art, Boston
Riverside Studios, London; Ikon Gallery, Birmingham,
England; and Orchard Gallery, Derry, Northern Ireland.
Barbara Krakow Gallery, Boston
Galeria La Maquina Española, Madrid

1989 Jay Gorney Modern Art, New York
Galerie Johnen & Schöttle, Cologne
Dia Art Foundation, New York

Selected Group Exhibitions

1982 "Alternatives," The City Gallery, Department of Cultural
Affairs, New York
"Atlanta," Group Material, New York
Ronald Feldman Fine Arts, New York

1983 "Artists' Call," Brooke Alexander Gallery, New York
"Timeline," organized by Group Material, P.S.1, Institute
for Art & Urban Resources, Long Island City, New York
"The War Show," State University of New York at Stony Brook
"The State of the Art: The New Social Commentary,"
Barbara Gladstone Gallery, New York
"Act/React," S.P.A.R.C., Los Angeles

"Primer," Artists' Space, New York
"The 1984 Show," Ronald Feldman Fine Arts, New York

1984 "New Art of the Decade," Artists' Space, New York
"Identity and Illusion," Sarah Lawrence College,
Bronxville, New York
"Ansatzpunkte Kritischer Kunst Heute," Neue Gesellschaft
für Bildende Kunst, Berlin and Bonner Kunstverein,
Bonn
"Artists' Call," curated by Lucy Lippard, Colby College,
Waterville, Maine
"Olympiad," Kantor Gallery, Los Angeles
"Art for or Against," Thorpe Intermedia Gallery, Sparkill,
New York

1985 "Alarm Clock," organized by Group Material, Royal
Festival Hall, London
"Disinformation: The Manufacture of Consent," The
Alternative Museum, New York
"Americana," organized by Group Material, Biennial
Exhibition, Whitney Museum of American Art, New York
"Public Art," curated by Ronald Jones, Nexus Art Center,
Atlanta
"Social Studies" Barbara Gladstone Gallery, New York

1986 "Liberty and Justice," co-organized by Group Material
and The Alternative Museum, The Alternative Museum,
New York
Lawrence Oliver Gallery, Philadelphia
"MASS," organized by Group Material, The New
Museum, New York
"Gallery Artists," Jay Gorney Modern Art, New York
"Art and Its Double—A New York Perspective," curated by
Dan Cameron, Fundación Caja de Pensiones, Barcelona
and Madrid
Group show organized by Josh Baer and Rhona Hoffman,
Rhona Hoffman Gallery, Chicago
"Benefit for the Kitchen," Brooke Alexander Gallery,
New York
"Text and Image," Holly Solomon Gallery, New York
"Por Encima Del Bloqueo," Centro Wilfredo Lam,
Havana, Cuba

1987 "Art Out of the Studio: Community Settings," curated by Tom Finkelpearl and Glen Weiss, P.S.1, The Institute for Art & Urban Resources, Long Island City, New York
"Perverted by Language," curated by Robert Nickas, Hillwood Art Gallery, Long Island University, Greenvale, New York
"Resistance—Anti-Baudrillard," organized by Group Material, White Columns, New York
"The Art of the Real," curated by Robert Nickas, Galerie Pierre Huber, Geneva
"A Different Corner, Definition and Redefinition—Painting in America," curated by Christian Leigh, U.S. Pavilion, I Bienal Internacional de Pintura, Museo de Arte Moderno, Cuenca, Ecuador
"Romance," curated by Ronald Jones, Knight Gallery, Charlotte, North Carolina
Longwood Art Gallery, South Bronx, New York
"Similia/Dissimilia," curated by Rainer Crone, Städtisches Kunsthalle, Düsseldorf (traveled to Castelli Gallery, Sonnabend Gallery and Wallach Art Gallery, Columbia University, New York)
"The Castle," an installation by Group Material, Documenta 8, Kassel, West Germany
Robert Kaye Collection, Trenton, New Jersey
"Artchildren, Artselves," City Without Walls Gallery, Newark, New Jersey
"NY Art Now," The Saatchi Collection, London
"Constitution," organized by Group Material, Temple University Art Gallery, Philadelphia
"Recent Tendencies in Black and White," curated by Jerry Saltz, Sidney Janis Gallery, New York
"The Beauty of Circumstance," curated by Ronald Jones, Josh Baer Gallery, New York

1988 Jay Gorney Modern Art, New York
"Walk out to Winter," curated by Christian Leigh, Bess Cutler Gallery, New York
"Committed to Print," The Museum of Modern Art, New York
"Aperto," XLIII Esposizione Internationale d'Arte, La Biennale di Venezia, Venice
Lawrence Oliver Gallery, Philadelphia

"The BiNational: American Art of the Late 80's," Museum of Fine Arts and Institute of Contemporary Art, Boston; Kunstsammlung Nordrhein-Westfalen and Städtisches Kunsthalle, Düsseldorf
"ROSC," Dublin, Ireland
"AIDS and Democracy: A Case Study," organized by Group Material, Dia Art Foundation, New York

1989 "A Good Read: The Book as a Metaphor," Barbara Toll Fine Arts, New York
"Oberlin Alumni Collect: Modern and Contemporary Art," Allen Memorial Art Museum, Oberlin College, Oberlin, Ohio
"Word and Image," Lehman College Art Gallery, City University of New York, Bronx
"Horn of Plenty," curated by Gosse Oosterhof, Stedelijk Museum, Amsterdam

Outdoor Public Projects

1987 *Everyone Is Welcome.* "Messages to the Public," Public Art Fund Inc., Spectacular Light Board, Times Square, New York.

1988 *Amerika—For The People of Bathgate*, mural for Community Elementary School 4, 1701 Fulton Avenue, mural located at Bathgate Avenue between 173rd and 174th Streets, Bronx, New York. Commissioned by the Public Art Fund, Inc., New York.

BIBLIOGRAPHY

Abbe-Martin, Mary, "Bronx Artist Directs Local Student Effort," *The Star and Tribune*, Minneapolis, January 8, 1988.

Adams, Jill, "Art From the Heart," *Seventeen Magazine*, March 1989, pp. 70, 294–295.

The Alternative Museum and Group Material, eds., *Liberty and Justice*, exhibition catalogue, The Alternative Museum, New York, 1986.

Althorpe-Guyton, Marjorie, "NY Art Now," *Flash Art*, No. 137, November/December 1987, p. 109.

"Aperto 88," XLIII Esposizione Internazionale d'Arte, La Biennale di Venezia, General Catalogue, Venice, 1988.

Artner, Alan G., "Kids' Artistic View of Books a Noble Effort," *The Chicago Tribune*, November 13, 1987.

Berman, Marshall, "Can These Ruins Live?" *Parkett*, No. 20, Summer, 1989, pp. 42–55.

Bonner Kunstverein, *Ansatzpunkte Kritischer Kunst Heute* ("Points of Departure of Critical Art Today"), exhibition catalogue, Bonn, 1984.

Bredin, Lucinda, "A Touch of Art Class," *The Evening Standard* (London), July 28, 1988.

Brenson, Michael, "Art: Out of the Studio, Community Settings," *The New York Times*, February 6, 1987.

Brenson, Michael, "Tim Rollins + K.O.S. at Jay Gorney Modern Art," *The New York Times*, May 12, 1989, p. C28.

Brooks, Rosetta, "Tim Rollins + K.O.S.," *Artscribe*, No. 63, May 1987, pp. 40–47.

Cameron, Dan, "Against Collaboration," *Arts Magazine*, Vol. 58, No. 7, March 1984, pp. 83–87.

Cameron, Dan, "A Whitney Wonderland," *Arts Magazine*, Vol. 59, No. 10, Summer 1985, pp. 66–69.

Cameron, Dan, "Images and Quotation," *Artics* (Barcelona), No. 6, December 1986/January/February 1987, p.54.

Cameron, Dan, *Art and Its Double—A New York Perspective*, exhibition catalogue, Fundación Caja de Pensiones, Madrid, 1987.

Cameron, Dan, "A Special Supplement—Art and Its Double, A New York Perspective," *Flash Art*, No. 134, May 1987, pp. 57–72.

Cameron, Dan, *NY Art Now: The Saatchi Collection*. London: The Saatchi Collection, 1987.

Cameron, Dan, "The Art of Survival: A Conversation with Tim Rollins + K.O.S.," *Arts Magazine*, Vol. 62, No. 10, Summer 1988, pp. 80–83.

Cano Carreton, Vicente, "Tim Rollins y K.O.S.: El Arte a Frente a la Marginacion Social," *Vogue España*, December 1988.

Cathcart, Linda L., *A Decade of New Art*, exhibition catalogue, Artists' Space, New York, 1984.

Daniel, Marko, "The Art and Knowlege Workshop: A Study," *Tim Rollins + K.O.S.*, essay for exhibition catalogue, Riverside Studios, London, 1988, pp. 7–9.

Dimattia, Joseph, "Tim Rollins' Survival Course," *Art Papers* (Atlanta), Vol. 7, No. 6, February 1988, p. 11 and cover.

Donohoe, Victoria, "A Palette of Four Fresh Talents," *The Philadelphia Inquirer*, May 30, 1986.

Feaver, William, "Venice is Sinking . . ." *The Observer* (London), July 3, 1988.

Fairbrother, Trevor, "Interview with Tim Rollins," *The BiNational: American Art of the Late 80s*, exhibition catalogue, The Institute of Contemporary Art and The Museum of Fine Arts, Boston, 1988, pp. 168–174.

Fairbrother, Trevor, "'We Make the Future Tense,'" *Parkett*, Vol. 20, Summer 1989, pp. 74–89.

Feldman, Ronald and Carrie Rickey, "The 1984 Show," exhibition catalogue, Ronald Feldman Fine Arts, New York, 1983.

Fisher, Jean, "Tim Rollins + Kids of Survival," *Artforum*, Vol. XXV, No. 5, January 1987, p. 111.

Fisher, Jean, "The Nature Theatre of the South Bronx," *Tim Rollins + K.O.S.*, essay for exhibition catalogue, Riverside Studios, London, 1988, pp. 4–5.

Glueck, Grace, "Social Studies," *The New York Times*, June 28, 1985.

Glueck, Grace, "Survival Kids Transform Classics to Murals," *The New York Times*, November 13, 1988, pp. 1 and 42.

Graham-Dixon, Andrew, "From the Bronx to Hammersmith: Tim Rollins + K.O.S.—Beyond Child's Play," *The Independent* (London), July 26, 1988, p. 15.

Greater London Council, *The Other America*, exhibition catalogue, Royal Festival Hall, London 1985.

Hess, Elizabeth, "Class Conscious," *The Village Voice*, November 25, 1986, p. 92.

Hess, Elizabeth, "Graffiti R.I.P." *The Village Voice*, March 29, 1988.

Hilston, Tim, "Holding up a Mirror," *The Guardian* (London), July 27, 1988.

Hilston, Tim, "Kid's Stuff," *The Guardian* (London), August 3, 1988.

Howe, Katherine, "The Atomic Salon," *Images and Issues*, September/October, 1982.

Indiana, Gary, "Tim Rollins + K.O.S. at Jay Gorney Modern Art," *Art in America*, Vol. 75, No. 3, March 1987, pp. 137–138.

Januszcak, Waldemar, "Artful Dodge in the Bronx," *The Guardian* (London), September 22, 1987.

Jarque, Fietta, "Los K.O.S., un grupo de muchachos del Bronx que irrumpe en el mercado del Artè Neoyorquino," *el Pais* (Madrid), February 11, 1987.

Jones, Ronald, "Tim Rollins + K.O.S. at Jay Gorney Modern Art," *Flash Art* No. 132, March 1987, p. 107.

Joselit, David, *Currents: Tim Rollins + K.O.S.*, exhibition brochure, Institute of Contemporary Art, Boston, 1988.

Kaplan, Fran, "Exhibition Notes," text to accompany exhibition, Knight Gallery, Charlotte, North Carolina, 1987.

Kent, Sarah, "Bronx Break," *Time Out* (London), September 23–30, 1987, pp. 20–21.

Koslow, Francine A., "Tim Rollins + K.O.S.: The Art of Survival," *The Print Collectors' Newsletter*, Vol. XIX, No. 4 September/October 1988, pp. 139–142.

Kessler, Jane, "Kids of Survival: Tim Rollins + K.O.S.," *Art Papers* (Atlanta), March/April 1988.

Kuspit, Donald, "Crowding the Picture: Notes on American Activist Art Today," *Artforum*, Vol. XXVI, No. 9, May 1988, p. 117 and cover.

Lee, David, "Classics from the Street," *The Times* (London), July 27, 1988.

Leigh, Christian ed., *A Different Corner, Definition and Redefinition—Painting in America*, exhibition catalogue, Museo de Arte Moderno, Cuenca, Ecuador, 1987.

Leigh, Christian, "Art on the Verge of a Nervous Breakdown," *Contemporanea*, Vol. 2, No. 1, January/February, 1989, pp. 99–103.

Levin, Kim, "Out of the Studio: Art with the Community," *The Village Voice*, March 10, 1987, p. 86.

Levin, Kim, "Tim Rollins + K.O.S. at Jay Gorney Modern Art," *The Village Voice*, May 23, 1989, p. 94.

Liebmann, Lisa, "At the Whitney Biennial: Almost Home," *Artforum*, Vol. XXIII, No. 10, Summer 1985, pp. 57–61.

Lippard, Lucy, *Get the Message?*, New York: Dutton Inc., 1984.

Lippard, Lucy, *Reading From Reality*, essay to accompany exhibition, Lawrence Oliver Gallery, Philadelphia, 1987.

Lipson, Karin, "Works of Art by Any Means Necessary," *Newsday*, March 18, 1986.

Lipson, Karin, "Creativity with the Public's Blessing," *Newsday*, February 2, 1987.

Mahoney, Robert, "Reading Art: Tim Rollins + K.O.S.," *The New York Press*, April 13, 1988.

McFaydyean, Melanie, "The Art of Survival," *The Guardian* (London) May 13–14, 1989.

Morell, Ricki, "New York Art Program Visits N.C.," *The Charlotte Observer*, November 22, 1987.

Morgan, Ann Lee, "New York Group Show," *New Art Examiner* (Chicago), September 1986, pp. 47–48.

Nickas, Robert, "Art and Its Double," *Flash Art*, No. 132, March 1987, p. 113.

Nickas, Robert, ed., *The Art of the Real*, exhibition catalogue, Galerie Pierre Huber, Geneva, 1987.

Nickas, Robert, ed., *Perverted by Language*, exhibition catalogue, Hillwood Art Gallery, Long Island University, Greenvale, New York, 1987.

Nilson, Lisbet, "From Dead End to Avant-Garde," *Art News*, Vol. 87 No. 9, December 1988, pp. 133–137.

Pass, Louise, "Tim Rollins + His 'Kids of Survival,'" *The Arts Journal*, December 1984, pp. 4–5.

Parkett, "Collaboration Tim Rollins + K.O.S.," No. 20, Summer 1989, pp. 36–117.

Pincus-Witten, Robert, "Electrostatic Cling or the Massacre of Innocence," *Artscribe*, No. 64, Summer 1987, pp. 36–41.

Poetry East, *Poetry and the Visual Arts*, Ripon, Wisconsin, Summer 1985.

Rankin-Reid, Jane, "Tim Rollins + K.O.S.," *Tema Celeste*, No. 17–18, October/November 1988, p. 64.

Rinder, Lawrence, *Viewpoints: Tim Rollins + K.O.S.*, exhibition brochure, Walker Art Center, Minneapolis, 1988.

Robinson, Walter and Carlo McCormick, "Slouching Towards Avenue D, Report from the East Village," *Art In America*, Vol. 72, No. 6, Summer 1984, pp. 134–161.

Rodriquez, Geno and Noam Chomsky, *Disinformation: the Manufacture of Consent*, exhibition catalogue, The Alternative Museum, New York, 1985, pp. 60–61.

Rollins, Tim, "Art as Social Action: An Interview with Conrad Atkinson," *Art in America*, Vol. 68, No. 2, February 1980, pp. 118–123.

Rollins, Tim, "An Open Letter to Conrad Atkinson," in Nairne, Lippard, Tisdall, Rollins, *Picturing the System*, Institute of Contemporary Art, London, 1981, pp. 80–83.

Rollins, Tim, "Five Big Problems for Artists" and "Art and Guns," *Poetry East*, Winter 1982/Spring 1983, pp. 148–152.

Rollins, Tim, "The Making of 'Amerika,'" *Figura* (Sevilla, Spain), No. 6, Summer 1985, pp. 17–19.

Rollins, Tim, "Tim Rollins + K.O.S.," in Jerry Saltz, ed., *Beyond Boundaries—New York's New Art*, New York: Alfred van der Marck Editions, 1986, p. 127.

Rollins, Tim, ". . . From The Working Journal," *A Different Corner, Definition and Redefinition—Painting in America*, exhibition catalogue, Museo de Arte Moderno, Cuenca, Ecuador, 1987, pp. 22–25.

Rollins, Tim, "Tim Rollins + K.O.S.," *Parkett*, No. 20, Summer 1989, pp. 36–39.

Rollins, Tim + K.O.S., "Dialogue 1," *Tim Rollins + K.O.S.*, exhibition catalogue, Riverside Studios, London, 1988 pp. 12–16.

Rollins, Tim + K.O.S., "Dialogue 2," *Tim Rollins + K.O.S.*, exhibition catalogue, Riverside Studios, London, 1988 pp. 25–29.

Rollins, Tim + K.O.S., "Dialogue 5," *Parkett*, No. 20, Summer 1989, pp. 56–71.

Russell, John, "At the Saatchi Collection, A Thin Show of NY Art," *The New York Times*, January 3, 1988.

Saltz, Jerry, ed., *Beyond Boundaries—New York's New Art*. New York: Alfred van der Marck Editions, 1986.

Smith, Roberta, "Art: A Collaboration, Tim Rollins + K.O.S.," *The New York Times*, November 21, 1986.

Smith, Roberta, "Artworks That Strike Up Conversations With Viewers," *The New York Times*, April 1, 1988.

Sola, Michele, "Just Take it Step by Step: An Interview with Tim Rollins of the Kids of Survival Crew," *Radical Teacher Magazine* No. 33, 1988.

Stapen, Nancy, "The Medium Has a Message," *Elle Magazine*, March 1989.

Sturman, John, "Tim Rollins + K.O.S. at Jay Gorney Modern Art," *Artnews*, Vol. 84, No. 6, Summer 1985, p. 190.

Temin, Christine, "Tim Rollins + K.O.S.," *The Boston Globe*, April 17, 1988.

Tsai, Eugenia, "Tim Rollins + K.O.S.," in Rainer Crone, ed., *Similia/Dissimilia*. New York: Rizzoli, 1987, pp. 149–154.

Walker, Richard W., "The Saatchi Factor," *Artnews*, Vol. 86, No. 1, January 1987, pp. 117–121.

Photo Credits

Photographs of *Amerika I, II, III, IV, V, VI, IX, X, XII*, and *Amerika: For Thoreau* by Lary Lamé.

Photograph of *Amerika VII*, courtesy of Lawrence Oliver Gallery, Philadelphia and the Phildelphia Museum of Art.

Photograph of *Amerika VIII*, courtesy of Rhona Hoffman Gallery, Chicago and The Museum of Modern Art, New York.

Photograph of *Amerika XI*, courtesy of First Bank System, Inc., Minneapolis.

Photograph of Bathgate mural by Peter Bellamy.

Photographs of Study Drawings by Oren Slor.

Reference Photographs 2, 23, 31–33, courtesy of Jay Gorney Modern Art, New York.